COMICS AND SEQUENTIAL ART

The Will Eisner Library
from W. W. Norton & Company

HARDCOVER COMPILATIONS

The Contract With God *Trilogy: Life on Dropsie Avenue*
Will Eisner's New York: Life in the Big City
Life, in Pictures: Autobiographical Stories

PAPERBACKS

A Contract With God
A Life Force
Dropsie Avenue
New York: The Big City
City People Notebook
Will Eisner Reader
The Dreamer
Invisible People
To the Heart of the Storm
Life on Another Planet
Family Matter
Minor Miracles
The Name of the Game
The Building
The Plot: The Secret Story of the Protocols of the Elders of Zion

INSTRUCTIONAL TEXTBOOKS

Comics and Sequential Art
Graphic Storytelling and Visual Narrative
Expressive Anatomy for Comics and Narrative

OTHER BOOKS BY WILL EISNER

Fagin the Jew
Last Day in Vietnam
Eisner/Miller
The Spirit Archives
Will Eisner Sketchbook
Will Eisner's Shop Talk
Hawks of the Seas
The Princess and the Frog
The Last Knight
Moby Dick
Sundiata

COMICS AND SEQUENTIAL ART

PRINCIPLES AND PRACTICES FROM THE LEGENDARY CARTOONIST

A Will Eisner Instructional Book

W. W. NORTON & COMPANY
NEW YORK · LONDON

For information about permission to reproduce selections from this book, write to Permissions, W. W. Norton & Company, Inc., 500 Fifth Avenue, New York, NY 10110

For information about special discounts for bulk purchases, please contact W. W. Norton Special Sales at specialsales@wwnorton.com or 800-233-4830

Manufacturing by RR Donnelley, Willard
Book design by Grace Cheong, Black Eye Design, blackeye.com
Production manager: Devon Zahn
Digital production: Sue Carlson, Joe Lops, and Alex Price

Produced in Association with:
The Center for Cartoon Studies
White River Junction, Vermont
cartoonstudies.org

Library of Congress Cataloging-in-Publication Data

Eisner, Will.
Comics and sequential art : principles and practices from the legendary cartoonist / Will Eisner.
p. cm.
Rev. ed. of: Comics & sequential art. 1985.
Includes index.
ISBN 978-0-393-33126-4 (pbk.)
1. Comic books, strips, etc.—Technique. 2. Drawing—Technique.
I. Eisner, Will. Comics & sequential art. II. Title.
NC1764.E47 2008
741.5'1—dc22
 2008020042

W. W. Norton & Company, Inc.
500 Fifth Avenue, New York, N.Y. 10110
www.wwnorton.com

W. W. Norton & Company Ltd.
Castle House, 75/76 Wells Street, London W1T 3QT

2 3 4 5 6 7 8 9 0

CONTENTS

EDITOR'S NOTE

AFTER NEARLY THIRTY PRINTINGS, WILL EISNER'S *Comics and Sequential Art* is well established as a primary treatise on the theory and mechanics of modern comics. Since its inception in 1985 the book has regularly been subject to updates and revisions by its author. Eisner intended for all three of his educational/instructional books to be living textbooks with long shelf lives and continuing utility. It is in that spirit that this posthumous W. W. Norton edition, the first by a new publisher, respectfully incorporates additional changes.

The original editions of this book and its first companion volume, *Graphic Storytelling and Visual Narrative*, were published by Poorhouse Press, a tiny imprint operated on a very part-time basis by Will Eisner himself, and largely overseen by his late brother Pete, who had retired some years earlier. Ever the ambitious businessman as well as creator, Eisner decided to self-publish his educational titles to keep a foot in all aspects of the comics industry. (*Expressive Anatomy for Comics and Narrative,* the final volume of his educational trilogy, was first published after Eisner's death.)

While Eisner was solely responsible for the editorial side of the Poorhouse Press volumes, all of his numerous graphic novels, magazines and comic books were being published and designed by professional organizations in America and overseas, and he was not, during that stage of his long career, running a true publishing operation. Thus, the Poorhouse Press editions, though commercially successful—as dozens of printings attest—were assembled without the benefit of today's sophisticated scanners or professional art direction. Most of the illustrations, including Eisner's own art, were delivered to Poorhouse's printer as mechanical boards comprised of simple Xeroxed pasteups or less-than-perfect photostats.

As a result, the printed version of most images suffered considerably in transition.

For the new W. W. Norton editions, virtually all of the illustrations have been scanned directly from Eisner's archived original art or, in the case of other artists' work in the companion volumes, from the best available source materials. In some cases altogether new images were used, including alternate images from Eisner's out-takes file.

In keeping with the author's wishes, we have updated the text, where necessary, to remove anachronisms and to reflect the current state of the industry and technology. Minor grammatical errors were corrected and some new text was added for clarity. With the assistance of James Sturm at the Center for Cartoon Studies, new "sidebars" were added to bring more contemporary art examples to the work. The expertise of Gary Chaloner (Eisner's collaborator on *John Law*) was essential in updating portions relating to the ever-changing digital comics world. The careful work of Margaret Maloney was invaluable in helping update and finalize the manuscript. Finally, with input from Sturm, these elements were given to Michel Vrana, an exceptional designer with long experience in the comics field, and to Grace Cheong, who expertly and elegantly redesigned the book. The guidance and ultimate approval of the estate, primarily Ann Eisner and Carl and Nancy Gropper, along with the steady oversight of Bob Weil and Lucas Wittmann at Norton, was at all times appreciated. The final results, we are confident, would very much please the author.

Denis Kitchen

—Denis Kitchen

FOREWORD

THIS WORK IS INTENDED TO CONSIDER AND EXAMINE the unique aesthetics of sequential art as a means of creative expression, a distinct discipline, an art and literary form that deals with the arrangement of pictures or images and words to narrate a story or dramatize an idea. It is studied here within the framework of its application to comic books and comic strips, where it is universally employed.

This ancient form of art, or method of expression, has found its way to the widely read comic strips, books and graphic novels which have established an undeniable position in the popular culture in the past century. It is interesting to note that sequential art has only fairly recently emerged as a discernible discipline alongside film-making, to which it is truly a forerunner.

Comics have undoubtedly enjoyed wide popularity worldwide. However, for reasons having much to do with usage, subject matter and perceived audience, sequential art was for many decades generally ignored as a form worthy of scholarly discussion. While each of the major integral elements, such as design, drawing, caricature and writing, have separately found academic consideration, this unique combination took a long time to find a place in the literary, art and comparative literature curriculums. I believe that the reason for slow critical acceptance sat as much on the shoulders of the practitioner as the critic.

Thoughtful pedagogical concern has also increasingly provided a better climate for the production of worthy subject content and the expansion of the medium as a whole. When I first wrote this book in 1985 I was concerned that unless more comics addressed subjects of greater moment they could not, as a genre, hope for serious intellectual review. As I often lectured my students, "Great artwork alone is not enough." I've been gratified, in the two decades following the initial publication of *Comics and Sequential Art* and *Graphic Storytelling* (*Expressive Anatomy for Comics and Narrative* is being published posthumously—Editor's Note) to observe an increasing number of artists and writers in this medium ambitiously pursue a wide range of cerebral topics and to see commensurate appreciation by the larger culture.

The premise of this book is that the special nature of sequential art is deserving of serious consideration by both critic and practitioner. The

modern acceleration of graphic technology and the emergence of an era greatly dependent on visual communication make this increasingly inevitable.

This work was originally written as a series of essays that appeared randomly in *The Spirit Magazine*. They were an outgrowth of my teaching a course in Sequential Art at the School of Visual Arts in New York City. Organizing the syllabus for this course brought into sharp focus the fact that during most of my professional life, I had been dealing with a medium more demanding of diverse skills and intellect than I or my contemporaries fully appreciated. Traditionally, most practitioners with whom I worked and talked produced their art viscerally. Few ever had the time or the inclination to diagnose the form itself. In the main they were content to concentrate on the development of their draftsmanship and their perception of the audience and the demands of the marketplace.

I began to dismantle the complex components of the medium. I addressed the elements hitherto regarded as "instinctive" and tried to examine the art form's parameters. In doing so I found that I was involved with an "art of communication" more than simply an application of art. My goal in this book is to address the principles and practice of the world's most popular art form in a manner that is both thought provoking and pragmatic to student and professional alike.

———————

It is always difficult to allocate fairly the credit for the assistance one gets in a work of this kind because much of it comes indirectly. I wish to thank Professor Tom Inge, who encouraged the idea of this effort at the inception; Catherine Yronwode, who contributed generous and thoughtful editorial support; and the hundreds of students I have had the pleasure of working with during my years at the School Of Visual Arts. It was in the process of trying to serve the eager interest and learning demands of SVA students that I was able to develop the structure of this book.

Will Eisner

—Will Eisner

COMICS AND SEQUENTIAL ART

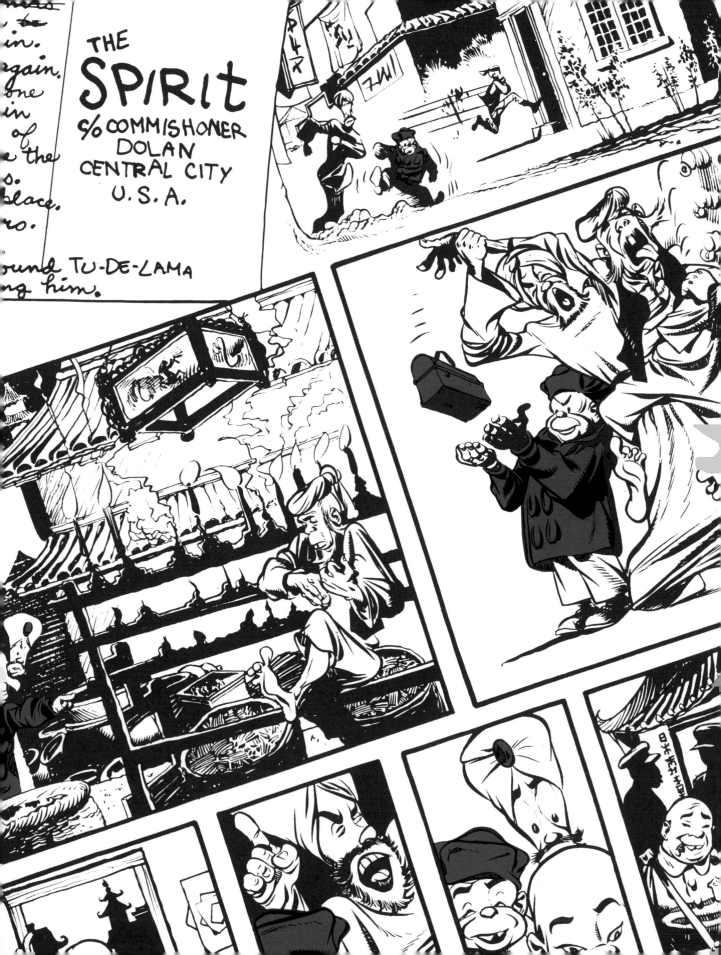

CHAPTER 1

COMICS AS A FORM OF READING

In modern times daily newspaper strips, comic books and more recently, graphic novels provide the major outlets for sequential art. For many decades the strips and comic books were printed on low-grade newsprint never intended for long shelf life. The often-ancient presses utilized for printing comic books and Sunday strips could not even guarantee proper color registration or clarity of line. As the form's potential has become more apparent, better quality and more expensive production has become more commonplace. This, in turn, has resulted in slick full-color publications that appeal to a more sophisticated audience, while black-and-white comic books printed on good paper have found their own constituency. Comics continue to grow as a valid form of reading.

The first comic books (circa 1934) generally contained a random collection of short features. Now, after nearly three quarters of a century, the routine appearance of complete "graphic novels" has, more than anything else, brought into focus the parameters of their structure. When one examines a comic book feature as a whole, the deployment of its unique elements takes on the characteristic of a language. The vocabulary of sequential art has been in continuous development in America. From the first appearance of comic strips in the daily press at the turn of the twentieth century, this popular reading form found a wide audience and in particular was a part of the early literary diet of most young people. Comics communicate in a "language" that relies on a visual experience common to both creator and audience. Modern readers can be expected to have an easy understanding of the image-word mix and the traditional deciphering of text. Comics can be "read" in a wider sense than that term is commonly applied.

Tom Wolf, writing in the *Harvard Educational Review* (August 1977) summarized it this way: "For the last hundred years, the subject of reading has been connected quite directly to the concept of literacy; . . . learning to read . . . has meant learning to read words. . . . But . . . reading has gradually

come under closer scrutiny. Recent research has shown that the reading of words is but a subset of a much more general human activity, which includes symbol decoding, information integration and organization....Indeed, reading—in the most general sense—can be thought of as a form of perceptual activity. The reading of words is one manifestation of this activity; but there are many others—the reading of pictures, maps, circuit diagrams, musical notes..."

For more than a century comic book and strip artists have been developing in their craft the interplay of words and images. They have in the process, I believe, achieved a successful crossbreeding of illustration and prose.

The format of comics presents a montage of both word and image, and the reader is thus required to exercise both visual and verbal interpretive skills. The regimens of art (e.g., perspective, symmetry, line) and the regimens of literature (e.g., grammar, plot, syntax) become superimposed upon each other. The reading of a graphic novel is an act of both aesthetic perception and intellectual pursuit.

To conclude, Wolf's reconsideration of reading is an important reminder that the psychological processes involved in viewing a word and an image are analogous. The structures of illustration and of prose are similar.

In its most economical state, comics employ a series of repetitive images and recognizable symbols. When these are used again and again to convey similar ideas, they become a distinct language—a literary form, if you will. And it is this disciplined application that creates the "grammar" of sequential art.

As an example, consider the final page from the *Spirit* story "Gerhard Shnobble," the story of a man who is determined to reveal to the world his ability to fly, only to be shot down by a stray bullet, his secret sealed forever by his pointless death (see FIGURE 1).

This concluding page depicts the death of Gerhard, who is collateral damage from a shootout on a rooftop. The first panel presents the reader with the climax of the story. A description of the action in this panel can be diagrammed like a sentence. The predicates of the gun shooting and the wrestling belong to separate clauses. The subject of "gun shooting" is the crook, and Gerhard is the direct object. The many modifiers include the adverb "Bang, Bang" and the adjectives of visual language, such as posture, gesture, and grimace.

The second panel concludes the subplot, and again uses the language of the body and the staging of graphic design to delineate the predicates.

The final transition requires the reader to break from the convention of the left-to-right sequence. The eye follows the air stream down past a nebulous background, onto the solid body on the ground, and then bounces back upward to view the half-tone cloud in which Gerhard is resurrected. This bounce is unique to the visual narrative. The reader must implicitly use his knowledge of physical laws (i.e., gravity, gases) to "read" this passage.

The accompanying text adds some nonillustrated thoughts hand-lettered in a style that is consistent with the sentiment that its message conveys. The visual treatment of words as graphic art is part of the vocabulary.

TEXT READS AS AN IMAGE

Lettering (hand-drawn or created with type), treated "graphically" and in the service of the story, functions as an extension of the imagery. In this

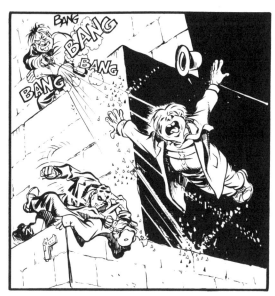

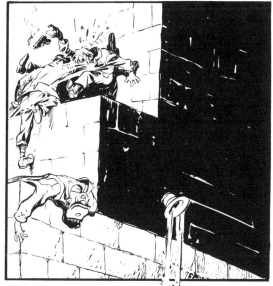

AND SO... LIFELESS...
GERHARD SHNOBBLE FLUTTERED
EARTHWARD.

BUT DO NOT WEEP
FOR SHNOBBLE...

RATHER SHED A TEAR
FOR ALL MANKIND...

FOR NOT ONE PERSON IN THE
ENTIRE CROWD THAT WATCHED
HIS BODY BEING CARTED AWAY...KNEW
OR EVEN SUSPECTED THAT
ON THIS DAY GERHARD SHNOBBLE
HAD **FLOWN**.

FIGURE 1

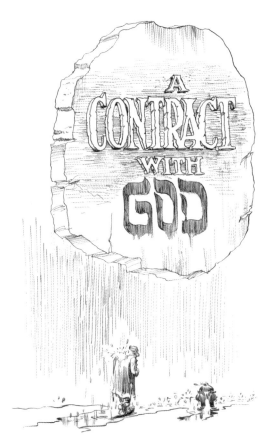

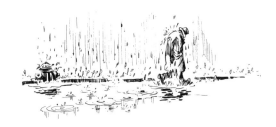

FIGURE 2

ABOVE: Here, the lettering is employed to support the "climate." Designing the typeface to permit it to be drenched by the rain converts the normally mechanical aspect of type into supportive involvement in the imagery.

context it provides the mood, a narrative bridge and the implication of sound. In an extract from my graphic novel *A Contract With God*, the use of, and treatment of text as a "block" is employed in a manner that conforms to such a discipline (see FIGURE 2).

The meaning of the title is conveyed by the employment of a commonly recognized configuration of a tablet. A stone is employed—rather than parchment or paper, for example, to imply permanence and evoke the universal recognition of Moses' Ten Commandments on a stone tablet. Even the mix of the lettering style—Hebraic vs. a condensed Roman letter—is designed to buttress this feeling.

Another example of how text rendered in concert with the art shows how the 'reading' of it can be influenced. In the following page from *The Spirit's Case Book of True Ghost Stories*, the dialogue executed in a certain manner tells the reader how the author wishes it to sound. In the process it evokes a specific emotion and modifies the image (see FIGURE 3).

FIGURE 3: (OPPOSITE) Compare this lettering style and treatment with the example above. Here, the effect of terror, implication of violence (blood) and anger brings the text into direct involvement.

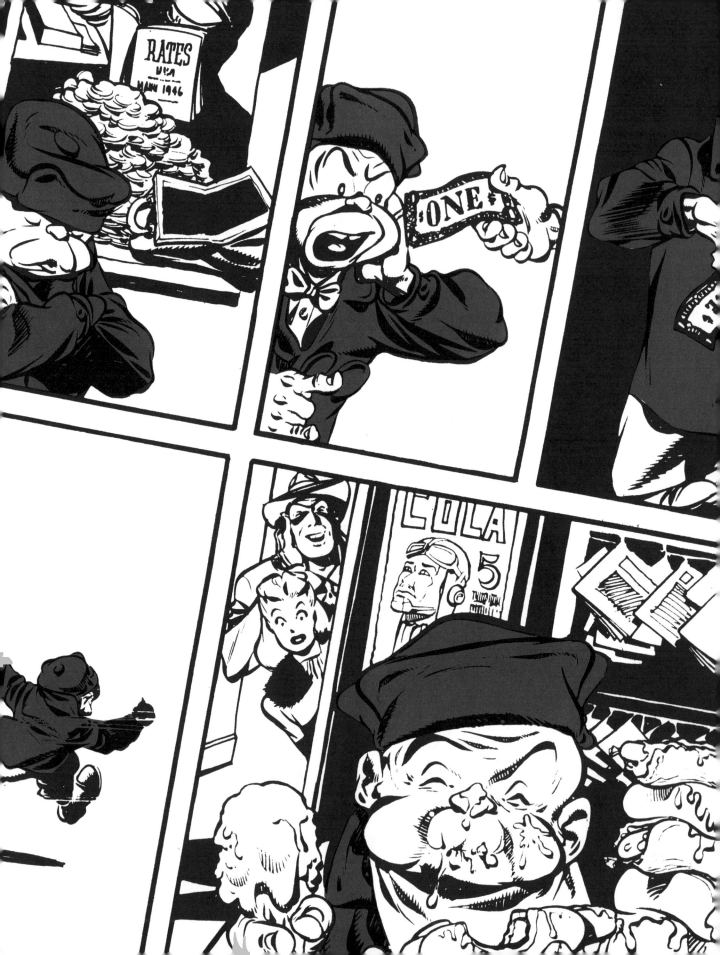

CHAPTER 2

IMAGERY

Comics deal with two fundamental communicating devices: words and images. Admittedly this is an arbitrary separation. But, since in the modern world of communication they are treated as independent disciplines, it seems valid. Actually, they are derivatives of a single origin and in the skillful employment of words and images lies the expressive potential of the medium.

This special mix of two distinct forms is not new. Their juxtaposition has been experimented with from earliest times. The inclusion of inscriptions employed as statements by the people depicted in medieval paintings was generally abandoned after the sixteenth century. Thereafter the efforts by the artists who sought to convey statements that went beyond decoration or portraiture were confined to facial expressions, postures, and symbolist backdrops. The use of inscriptions reappeared in broadsheets and popular publications in the eighteenth century. During the twentieth century, artists who dealt in story-bearing art for the mass audience sought to create a gestalt, some cohesive language, as the vehicle for the expression of a complexity of thoughts, sounds, actions and ideas in a sequenced arrangement separated by boxes. This stretched the capabilities of simple imagery. In the process the modern narrative art form, which we call comics (and the French call *bande dessinée*) evolved.

Today, this art form is evolving still. Across the twentieth century, the language of sequential art had developed primarily in print media such as comic book magazines and newspaper strips. Now, new forms of digital technology allow for the creative extension of the basic principles of storytelling discussed in this volume.

IMAGERY AS A COMMUNICATOR

Comprehension of an image requires a commonality of experience. This demands of the sequential artist an understanding of the reader's life experience if his message is to be understood. An interaction has to develop because the artist is evoking images stored in the minds of both parties. The success or failure of this method of communicating depends upon the ease with which the reader recognizes the meaning and

emotional impact of the image. Therefore, the skill of the rendering and the universality of form chosen are critical. The style and the appropriateness of technique become part of the image and what it is trying to say. In addition, today's sequential artist can choose to create work in traditional print media, the wide-open digital publishing world, or both. Each road offers advantages and options regarding techniques, distribution channels and demographic audiences, and each boasts avid and sometimes overlapping fan bases.

LETTERS AS IMAGES

Words are made up of letters. Letters are symbols that are devised out of images, which originate out of familiar forms, objects, postures and other recognizable phenomena. So, as their employment becomes more sophisticated, they become simplified and abstract.

In the development of Chinese and Japanese pictographs, a welding of pure visual imagery and a uniform derivative symbol took place. Ultimately, the visual image became secondary and the execution of the symbol alone became the arena of

style and invention, marking the transition from pictographs to characters. The art of calligraphy emerged from this simple rendering of symbols and ascended to become a technique that, in its individuality, evoked beauty and rhythm. In this way, calligraphy added another dimension to the

ABOVE: Chinese letter or pictograph rendered in two styles of brushstroke.

use of the pictograph. There is here a certain similarity to the modern comic strip if one considers the effect the cartoonist's style has upon the character of the total product.

In Chinese calligraphy the style of the brushstroke confines itself to beauty of execution. This is not unlike the style of a ballerina executing the same choreography as her predecessors but in a style that

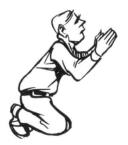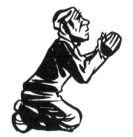

FIGURE 4: Egyptian **FIGURE 5:** Chinese

ABOVE: A rough example of the effect that "calligraphic" style has on the basic worship symbol as might be used in comics.

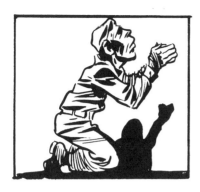
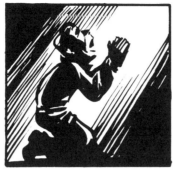
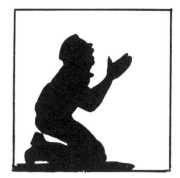

is, at once, unique and expressive of greater dimension. In comic art, the addition of style and the subtle application of weight, emphasis and delineation combine to evoke beauty and message.

Letters of a written alphabet, when written in a singular style, contribute to meaning. This is not unlike the spoken word, which is affected by the changes of inflection and sound level. For the purposes of illustration let us follow the progression of a single expression from ancient usage to the modern comic strip. The ancient Egyptian hieroglyph for the idea of worship was the symbol shown in FIGURE 4 and which the Chinese similarly depicted (see FIGURE 5).

In the modern comic strip the "pictograph" for worship would be conveyed with calligraphic style variations. Through lighting or "atmosphere" it could be modified in emotional quality. Finally, coupled with words, it would form a precise message to be understood by the reader.

LETTERS OF A WRITTEN ALPHABET, WHEN WRITTEN IN A SINGULAR STYLE, CONTRIBUTE TO MEANING.

It is here that the expressive potential of the comic artist is in the sharpest focus. After all, this is the art of graphic storytelling. The codification

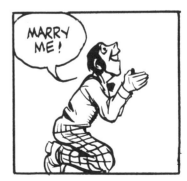

ABOVE: Here the underlying symbolic posture is given verbal and visual amplification. Dialogue, visually familiar objects (such as spears, architectural elements and costume) and facial expressions convey precise emotional messages.

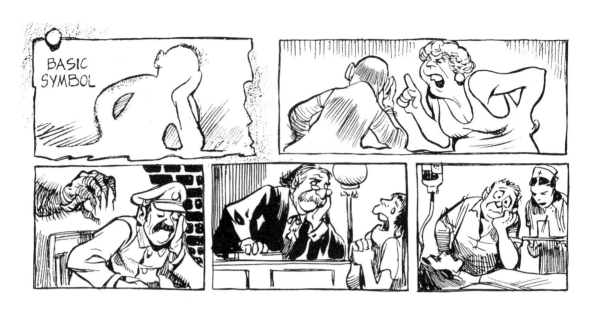

ABOVE: This basic symbol, derived from a familiar attitude, is amplified by words, costume, background and interaction (with another symbolic posture) to communicate meanings and emotion.

becomes, in the hands of the artist, an alphabet with which to make an encompassing statement that weaves an entire tapestry of emotional interaction.

By the skilled manipulation of this seemingly amorphic structure and an understanding of the anatomy of expression, the cartoonist can begin to undertake the exposition of stories that involve deeper meanings and deal with the complexities of human experience.

IMAGES WITHOUT WORDS

It is possible to tell a story through imagery alone without the help of words. The following *Spirit* story, "Hoagy the Yogi, Part 2" (first published March 23, 1947), executed entirely in pantomime, is an attempt to exploit imagery in the service of expression and narrative (see FIGURES 6 through 12). The absence of any dialogue to reinforce action serves to demonstrate the viability of images drawn from common experience.

IT IS POSSIBLE TO TELL A STORY THROUGH IMAGERY ALONE WITHOUT THE HELP OF WORDS.

FIGURE 6: (OPPOSITE) The postcards used here are meant to convey an element in the story that is as "visual" as the images of people. They are only peripherally narrative.

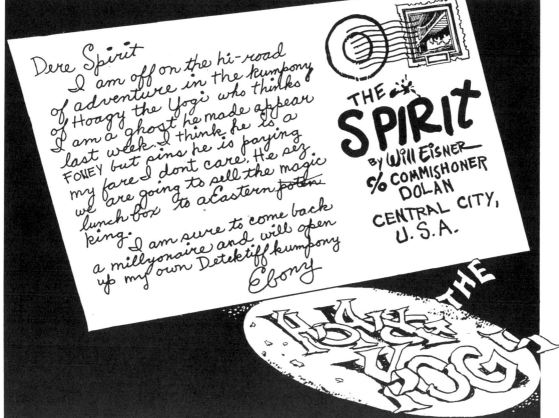

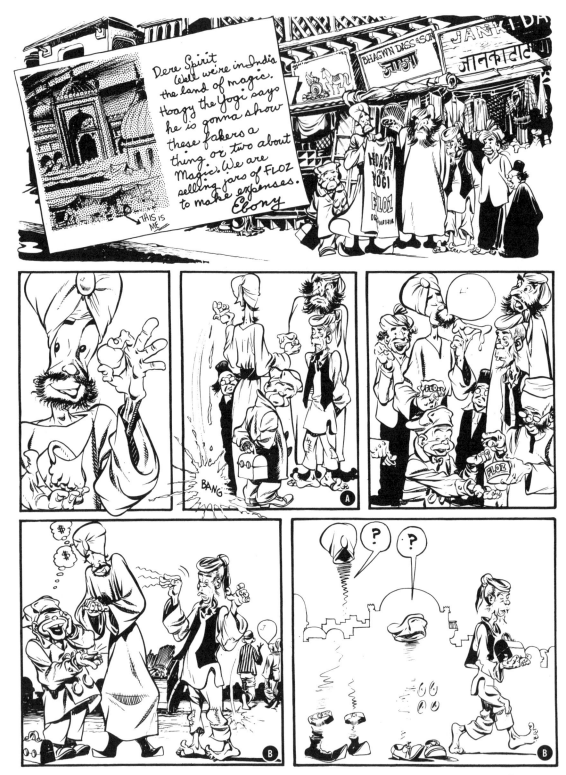

FIGURE 7: Ⓐ Words like **"BANG"** are used to add sounds, a dimension not really available to the printed medium. **Ⓑ** Symbols like **$** and **??** are used as thoughts rather than speech.

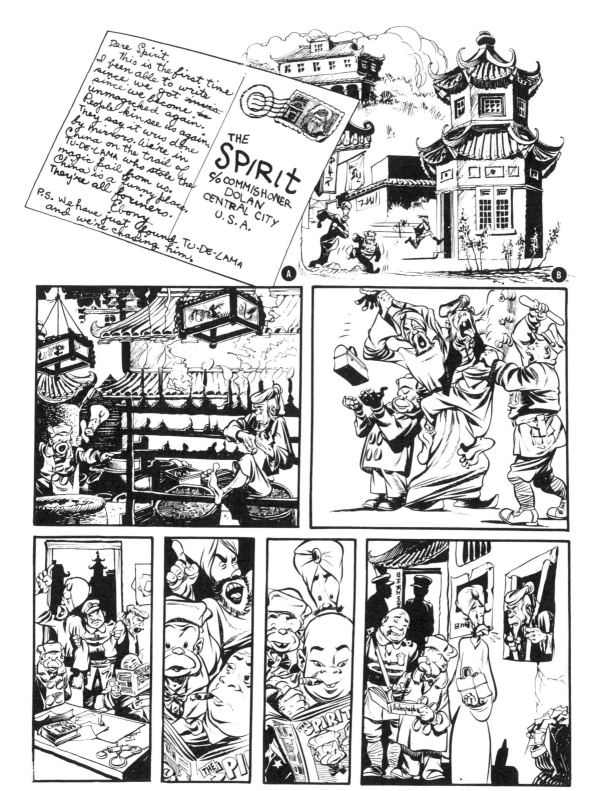

FIGURE 8: The rate of speed at which the action moves **"FORCES"** the reader to supply the dialogue. It is a phenomenon of comic strip reading that seems to work well. **A** The postcard and the text on it is at once a symbol and a narrative bridge. It is important here because it is necessary that the rhythm of pantomime, a visual language, flows undisturbed. **B** The changes of scenery serve to convey location.

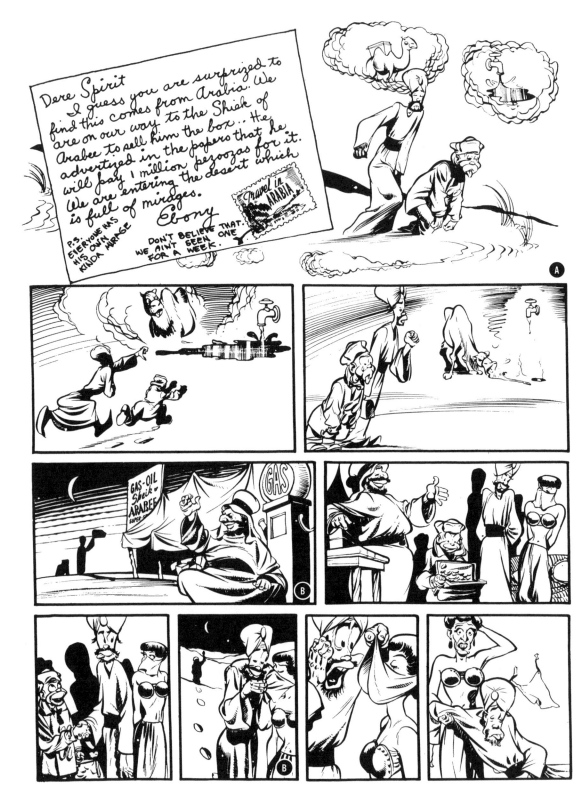

Comics and Sequential Art

FIGURE 9: Ⓐ Balloons, here, are confined to thoughts which are conveyed by images inside them. Ⓑ Commonly recognized images taken out of familiar experience convey action (footprints) and time (the moon).

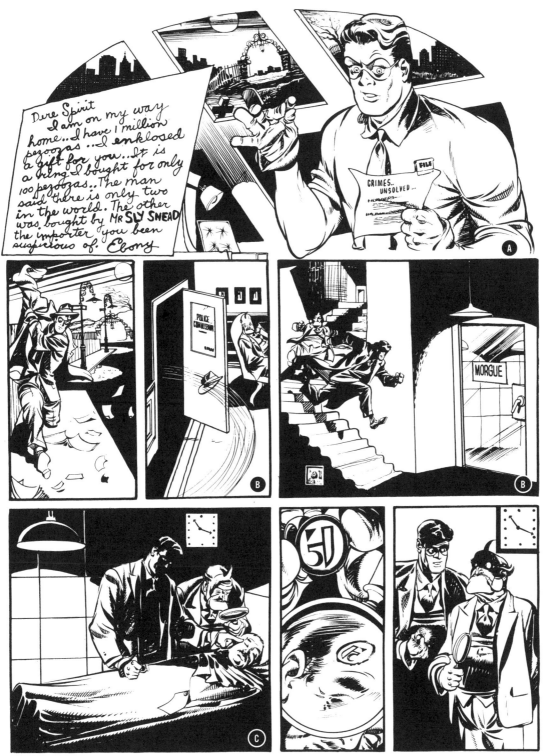

FIGURE 10: **Ⓐ** Facial expressions affecting the narrative require close-ups. **Ⓑ** and **Ⓒ** The door label and the position of the hat suspended in the speed stream are narrative devices. The clock on the wall fixes the lapse of time.

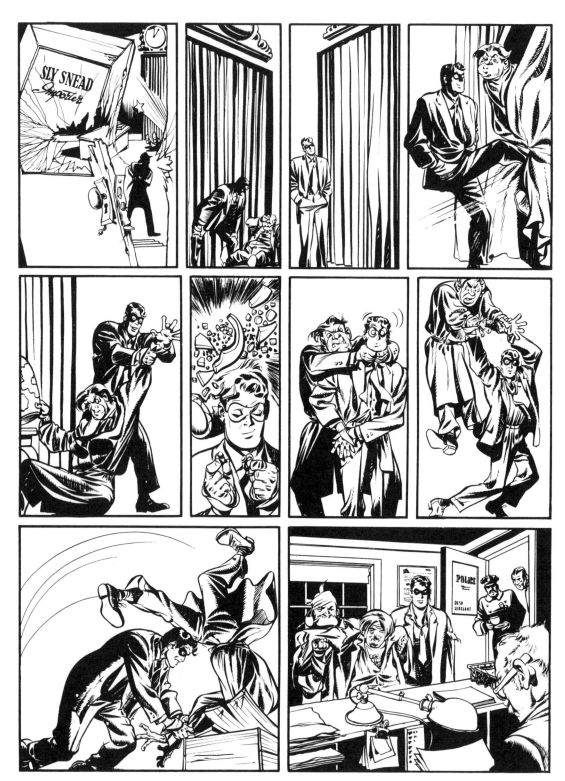

FIGURE 11: In pantomime, generally speaking, expression and gesture must be exaggerated in order to be effective.

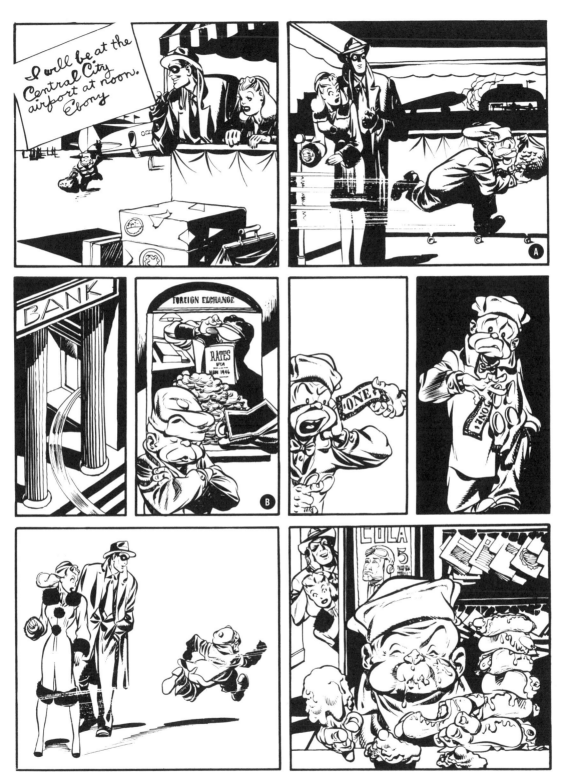

FIGURE 12: **Ⓐ** Speed lines indicate motion. They are part of the visual language. **Ⓑ** Background art is more than mere stage setting; it is a part of the narration.

"THE ABSENCE OF ANY DIALOGUE TO REINFORCE ACTION SERVES TO DETERMINE THE VIABILITY OF IMAGES DRAWN FROM COMMON EXPERIENCE."

THE NORWEGIAN CARTOONIST JASON HAS EARNED international attention for his deadpan and poetic stories. Combining banal details with surrealistic elements Jason's comics, drawn in a measured and distilled manner, explore common experiences like childhood, relationships and death.

In this two-page sequence, from his collection of stories entitled *SSHHHH!*, one of Jason's trademark anthropomorphic characters is being stalked by death. The lack of dialogue enhances the stories' haunting and humorous tone. Each page is deftly paced and, as required in pantomine storytelling, each panel is easy to read. Readers of any language can reflect on its universal themes.

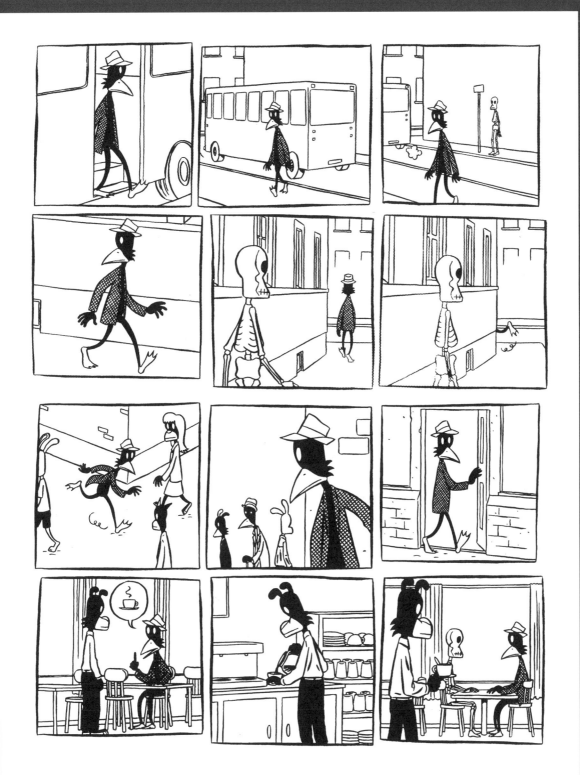

Images without words, while they seem to represent a more primitive form of graphic narrative, really require some sophistication on the part of the reader (or viewer). Common experience and a history of observation are necessary to interpret the inner feelings of the actor.

Sequential art as practiced in comics presents a technical hurdle that can only be negotiated with some acquired skill. The number of images allowed is limited, whereas in film or animation an idea or emotion can be expressed by hundreds of images displayed in fluid sequence at such speed as to emulate real movement. In print this effect can only be simulated. This challenge is not a disadvantage, however: in fact, it enables comics' singular ability to allow a reader to consider many images at the same time, or from different directions, a capability film lacks.

The intention in the following sequence (see FIGURE 13) is to let the viewer supply the dialogue, which is evoked by the images. The precise language is not important.

For example:

> **SHE:** "Oh, how my life is spent—ruined by living with you."
> **HE:** (No answer.)
> **SHE:** "You stupid fool…look at you! A weak nobody."
> **HE:** (Thinking.) "I can't stand it anymore… her damn nagging."
> **SHE:** "Stop sitting at the TV day after day. You do nothing!! Nothing!"
> **SHE:** "Listen, I'm telling you I'm not going to take much more of this."

COMMON EXPERIENCE AND A HISTORY OF OBSERVATION ARE NECESSARY TO INTERPRET THE INNER FEELINGS OF THE ACTOR.

This sequence from *Life on Another Planet* is yet another example of the narrative use of the image commonly experienced. Here, particularly because of the theme, with its demand for "real" emotion and sophisticated interaction, there is little room for ambiguity in art. The rendering of the line and the style of application, as in calligraphy, attempt to combine a sense of character with the appropriate emotional ingredients.

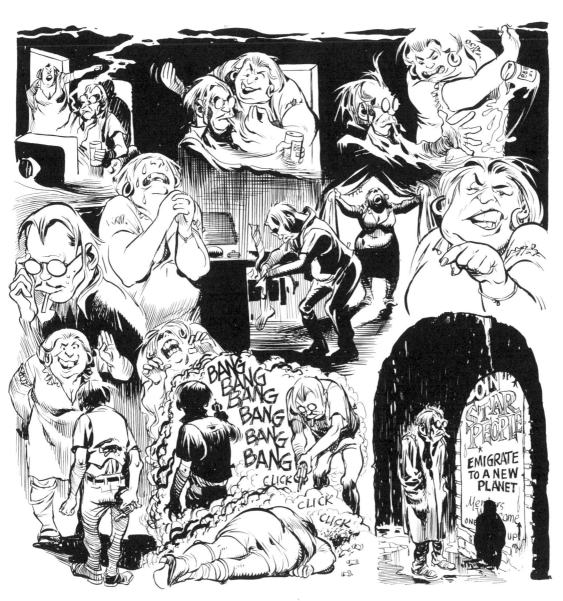

FIGURE 13

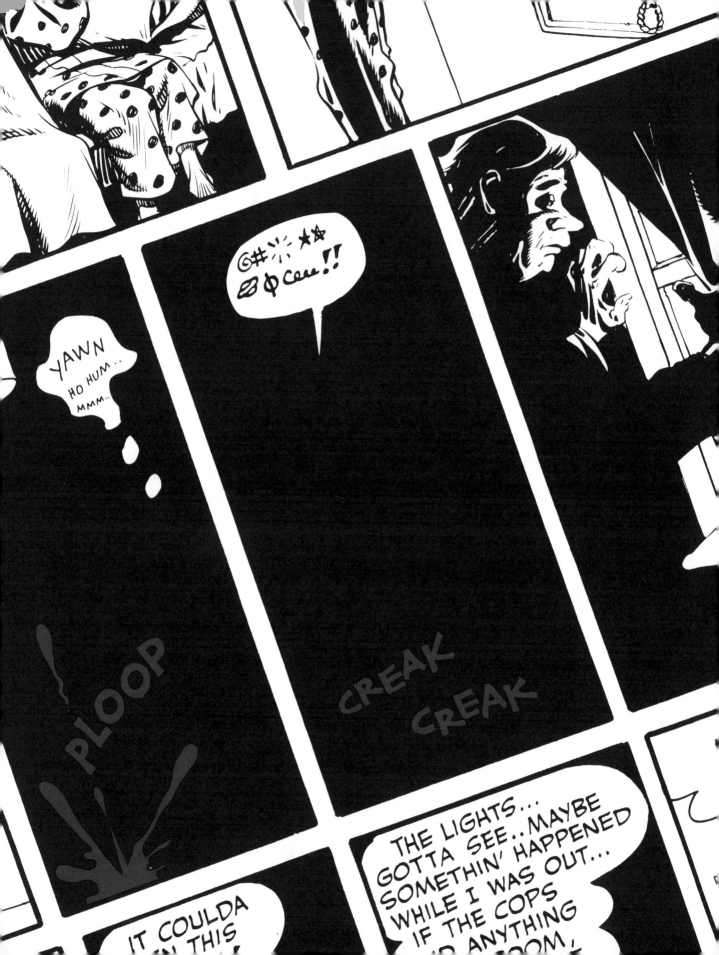

CHAPTER 3

TIMING

The phenomenon of duration and its experience—commonly referred to as "time"—is a dimension integral to sequential art. In the universe of human consciousness time combines with space and sound in a setting of interdependence wherein conceptions, actions, motions and movement have a meaning and are measured by our perception of their relationship to each other.

Because we are immersed throughout our lives in a sea of space-time, a large part of our earliest learning is devoted to the comprehension of these dimensions. Sound is measured audibly, relative to its distance from us. Space is mostly measured and perceived visually. Time is more illusory: we measure and perceive it through the memory of experience. In primitive societies the movement of the sun, the growth of vegetation or the changes of climate are employed to measure time visually. Modern civilization has developed a mechanical device, the clock, to help us measure time visually. The importance of this to human beings cannot be underestimated. Not only does the measurement of time have an enormous psychological impact, it enables us to deal with the real busi-

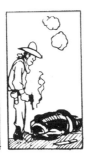

ABOVE: TIME—A simple action whose result is immediate, as it would be in reality.

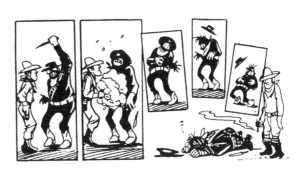

ABOVE: TIMING—A simple action wherein the result (only) is extended beyond its "actual" duration to enhance emotion.

ness of living. In modern society one might even say that it is instrumental to survival. In comics it is an essential structural element.

Critical to the success of a visual narrative is the ability to convey time. It is this dimension of human understanding that enables us to recognize and be empathetic to surprise, humor, terror and the whole range of human experience. In this theater of our comprehension, the graphic storyteller plies his art. At the heart of the sequential deployment of images intending to convey time is the commonality of its perception. But to convey "timing," which is the manipulation of the elements of time to achieve a specific message or emotion, panels become a critical element.

A comic becomes "real" when time and timing is factored into the creation. In music or the other forms of auditory communication where rhythm or "beat" is achieved, this is done with actual lengths of time. In graphics the experience is conveyed by the use of illusions and symbols and their arrangement.

FRAMING SPEECH

The balloon is a desperation device. It attempts to capture and make visible an ethereal element: sound. The arrangement of balloons which surround speech—their position in relation to each other, or to the action, or their position with respect to the speaker—contribute to the measurement of time. They are disciplinary in that they demand cooperation from the reader. A major requirement is that they be read in a prescribed sequence in order to know who speaks first. They address our subliminal understanding of the duration of speech.

Balloons are read following the same conventions as text (i.e., left-to-right and top-to-bottom in Western countries) and in relation to the position of the speaker. The earliest rendering of the balloon was simply a ribbon emerging from the speaker's mouth—or (in Mayan friezes) as brackets pointing to the mouth (see FIGURE 14). But as the balloon form developed, it too, became more

> # HAND LETTERING WILL ALWAYS BE THE MOST IDIOSYNCRATIC AND EXPRESSIVE MEANS OF INSERTING WORDS INTO BALLOONS AND TEXT PANELS.

sophisticated and its shape no longer just an enclosure. It took on meaning and contributed to the narration.

As balloons became more extensively employed their outlines were made to serve as more than simple enclosures for speech. Soon they were given the task of adding meaning and conveying the character of sound to the narrative (see FIGURE 15).

Inside the balloon, the lettering reflects the nature and emotion of the speech. It is most often symptomatic of the artist's own personality (style), as well as that of the character speaking. Emulating a foreign language style of letter and similar devices add to the sound level and the dimension of the character itself. Attempts to "provide dignity" to the comic strip are often tried by utilizing set-type or computer-generated type

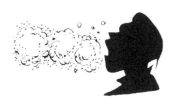 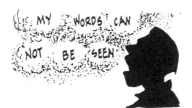 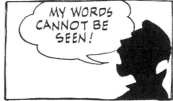

ABOVE: Steam from warm air expelled during conversation can be seen. It is logical to combine that which is heard within that which is seen resulting in a visualized image of the act of speaking. Americans call this a "balloon." Italians refer to speech clouds as "fumetti," thus, giving a generic name to their comics.

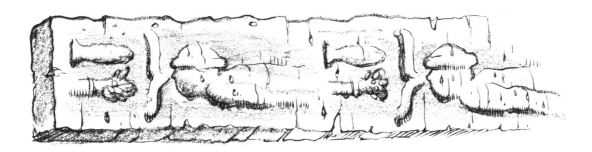

FIGURE 14

NORMAL SPEECH

"THOUGHT BALLOON" THAT IS ... AN UNSPOKEN SPEECH!

SOUND OR SPEECH THAT EMANATES FROM A RADIO, TELEPHONE, TELEVISION OR ANY MACHINE

FIGURE 15

THE READER'S ORIENTATION HELPS MEASURE THE TIME ELAPSED!

The reader's orientation helps measure the time elapsed.

FIGURE 16: A hand-lettered balloon conveys personality that is quite different from that of a typeset letter. It also has an effect on sound and style of speaking.

instead of the less rigid hand lettering (see FIG-URE 16). Typesetting does have a kind of inherent authority but it also has a "mechanical" effect that intrudes on the personality of freehand art.

There are both aesthetic and practical considerations in deciding how lettering should be handled, especially if artists either hate the often mundane task of lettering or are not particularly good at it. Hand lettering will always be the most idiosyncratic and expressive means of inserting words into balloons and text panels. Personal calligraphy assures that no two letters will be exactly alike and thus adds a recognizable "human" quality to graphic stories. Some cartoonists "subcontract" this task out to lettering specialists. Many artists (and collectors of cartoon art) prefer finished pages that are entirely original. If aesthetics do not demand hand lettering by the artist, many lettering and sound effect fonts are available for use on the Web—many actually based on other cartoonists' distinctive lettering—and are increasingly being used by cartoonists in place of time-consuming hand lettering. Personalized fonts can also be made based on an individual's own lettering style. An investment in computer fonts will save money compared to an artist's own labor or the continual hiring of professional letterers, but their use must be carefully considered both because of their effect on the "message" and because of their ease of misuse. An inexperienced comics artist may use a font designed for use in book text, which will look out of place in a comic, or he may not have the knowledge necessary to set type in a way that fits well in balloons. Errors like these can stick out like a sore thumb and distract the reader.

FRAMING TIME

Albert Einstein in his special theory of relativity states that time is not absolute but relative to the position of the observer. In essence the panel (or box) makes that postulate a reality for the comic book reader. The act of paneling, or boxing the action, not only defines its perimeters, it establishes the position of the reader in relation to the scene and indicates the duration of the event. Indeed, it effectively "tells" time. The magnitude of time elapsed is not expressed by the panel per se, as an examination of blank boxes in a series quickly reveals. The imposition of the imagery within the frame of the panels acts as the catalyst. The fusing of symbols, images and balloons makes the statement. Indeed, in some applications of the frame, the outline of the box is eliminated entirely with equal effect. The act of framing separates the scenes and acts as a punctuator. Once established and set in sequence the box or panel becomes the criterion by which to judge the illusion of time.

In the modern comic strip or comic book, the device most fundamental to the transmission of timing is the panel (or frame or box). These lines drawn around the depiction of a scene, which act as a containment of the action, or a segment of action, have as one of their functions the task of separating or parsing the total statement. Balloons, another containment device used for

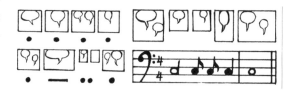

ABOVE: A MEASURE OF TIME—Morse code or a musical passage can be compared to a comic strip in that each employs the use of time in its expression.

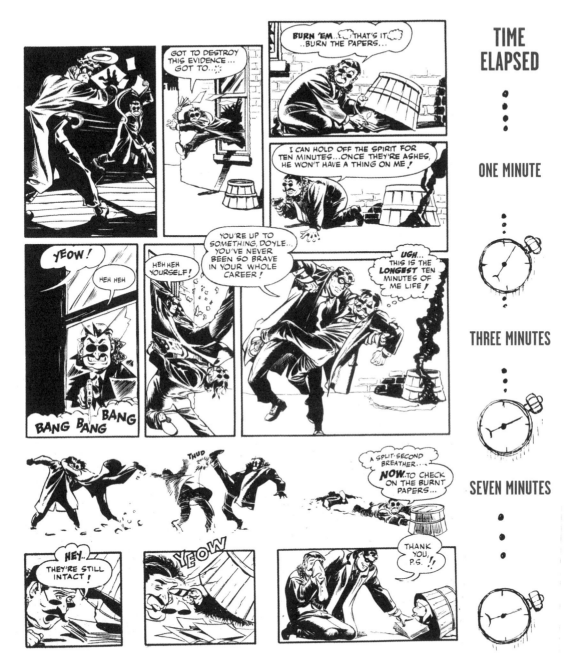

ABOVE: This extract from a *Spirit* story ("Prisoner of Love," first published January 9, 1949) deals with "timing." Here, the human action and a concurrent phenomenon (burning paper) are "timed" to create suspense. The "time" allowed to the fight is related to the time it presumably takes for the papers in the basket to burn. The shapes of the frames also contribute to the rhythm.

"CRITICAL TO THE SUCCESS OF A VISUAL NARRATIVE IS THE ABILITY TO CONVEY TIME."

ALISON BECHDEL'S *FUN HOME: A FAMILY TRAGICOMIC*, is a powerfully told family memoir. The story, rather than follow a straightforward narrative, is constructed like memory itself—jumping back and forth in time.

Alison is equally adept at making time stand still as she is at moving between decades. On this page, Alison and her brothers view their father's body at a funeral home. Employing five panels for this staid shot allows both for carefully observed details to be recorded and emotional impact to register on the reader.

HIS WIRY HAIR, WHICH HE HAD DAILY TAKEN GREAT PAINS TO STYLE, WAS BRUSHED STRAIGHT UP ON END AND REVEALED A SURPRISINGLY RECEDED HAIRLINE.

I WASN'T EVEN SURE IT WAS HIM UNTIL I FOUND THE TINY BLUE TATTOO ON HIS KNUCKLE WHERE HE'D ONCE BEEN ACCIDENTALLY STABBED WITH A PENCIL.

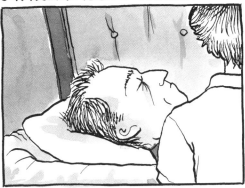

DRY-EYED AND SHEEPISH, MY BROTHERS AND I LOOKED FOR AS LONG AS WE SENSED IT WAS APPROPRIATE.

IF ONLY THEY MADE SMELLING SALTS TO INDUCE GRIEF-STRICKEN SWOONS, RATHER THAN SNAP YOU OUT OF THEM.

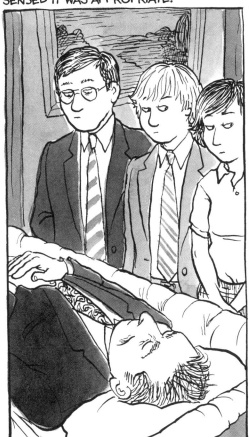

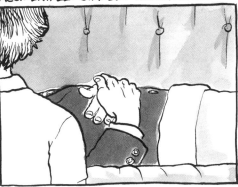

THE SOLE EMOTION I COULD MUSTER WAS IRRITATION, WHEN THE PINCH-FUNERAL DIRECTOR LAID HIS HAND ON MY ARM CONSOLINGLY.

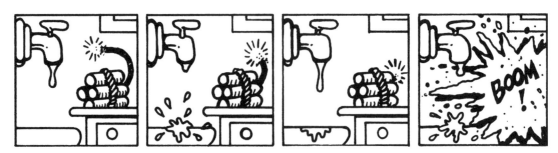

ABOVE: The reader's orientation, the knowledge of how long it takes a drop of water to fall from the faucet, modified by the number of panels, helps measure the time elapsed. This reinforces the burning down of the fuse. In fact, one could comprehend the time element without depicting the fuse.

the entrapment of the representation of speech and sound, are also useful in the delineation of time. The other natural phenomena, movement or transitory occurrences deployed within the perimeter of these borders and depicted by recognizable symbols become part of the vocabulary used in the expression of time. They are indispensable to the storyteller, particularly when he is seeking to involve the reader. Where narrative art seeks to go beyond simple decoration, where it presumes to imitate reality in a meaningful chain of events and consequences and thereby evoke empathy, the dimension of time is an inescapable ingredient.

These two devices—panel and balloon—when enclosing natural phenomena, are critical to supporting the recognition of time. J. B. Priestley, writing in *Man and Time,* summed it up most succinctly: "[I]t is from the sequence of events that we derive our idea of time."

In the following *Spirit* story, "Foul Play" (first published March 27, 1949), time is critical to the emotional elements in the plot (see FIGURES 17 through 23). It was necessary to frame a period of time that would encompass the plot. The problem was that a simple statement of time would not suffice. It would be too specific. It would mitigate the reader's involvement. A believable "time rhythm" had to be employed.

To accomplish this, a set of commonly experienced actions are used: a dripping faucet, striking a match, brushing teeth and the time it takes to negotiate a staircase.

The number and size of the panels also contribute to the story rhythm and passage of time. For example, when there is a need to compress time, a greater number of panels are used. The action then becomes more segmented, unlike the action that occurs in the larger, more conventional panels. By placing the panels closer together, we deal with the "*rate*" of elapsed time in its narrowest sense.

The shapes of the panels are also a factor. On a page where the need is to display a deliberate meter of action, the boxes are shaped as perfect squares. Where the ringing of the telephone needs time (as well as space) to evoke a sense of suspense and threat, the entire tier is given over to the action of the ringing preceded by a compression of smaller (narrower) panels.

In comics, timing and rhythm, as created by action and framing, are interlocked.

FIGURE 17: (OPPOSITE) The splash page provides an example of timing. Allowing two panels for the lapse of time prior to the dropping of the body, the element of shock, surprise and a bit of humor is introduced.

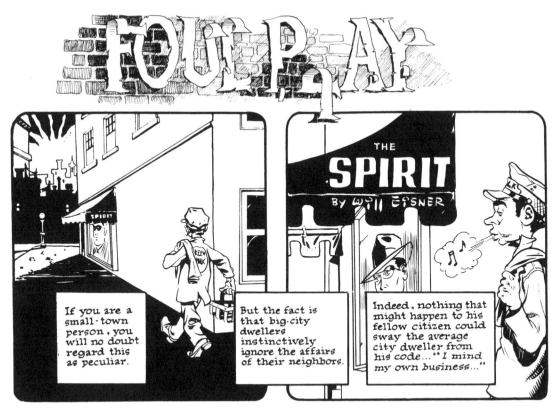

FOUL PLAY

If you are a small-town person, you will no doubt regard this as peculiar.

But the fact is that big-city dwellers instinctively ignore the affairs of their neighbors.

Indeed, nothing that might happen to his fellow citizen could sway the average city dweller from his code..."I mind my own business..."

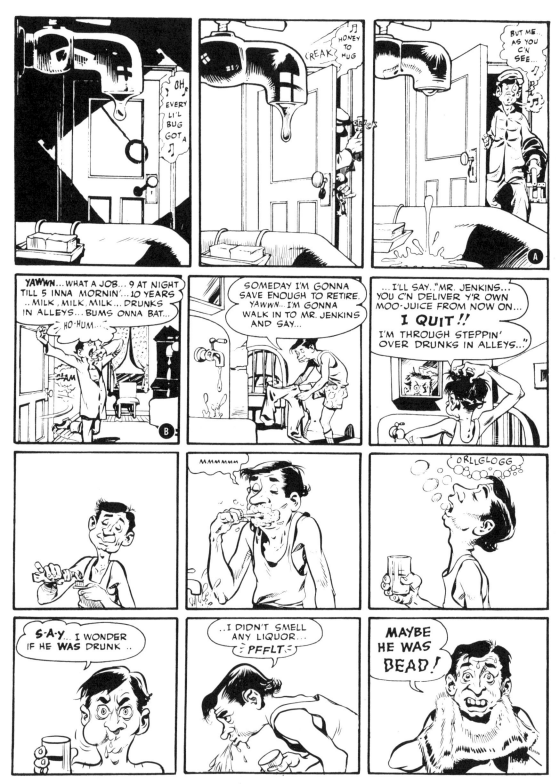

FIGURE 18: **Ⓐ** Here, the length of time it takes for a droplet to fall acts as a "clock." **Ⓑ** Timing and rhythm are interlocked. For example, the sudden introduction of a large number of small panels brings into play a new "beat."

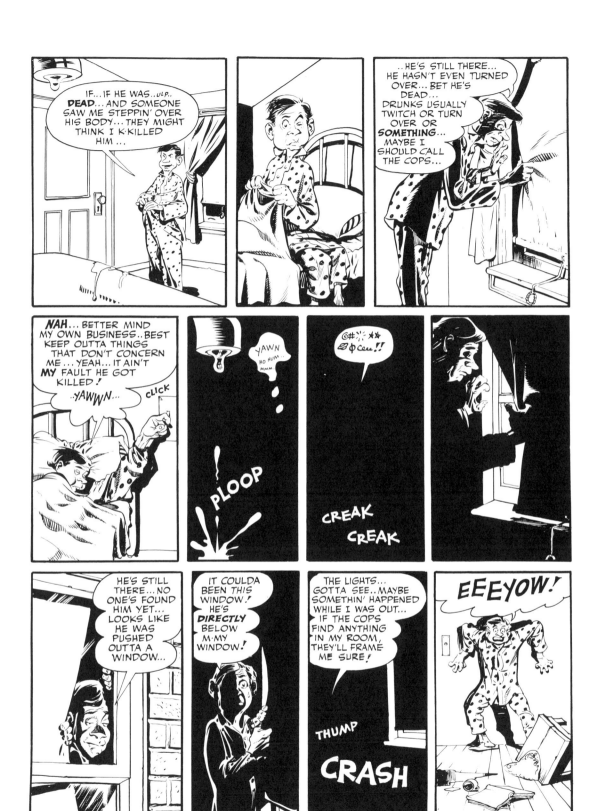

FIGURE 19: Long, narrow panels that create a crowded feeling enhance the rising tempo of panic.

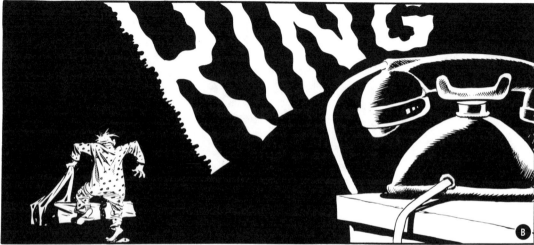

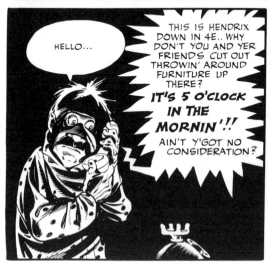

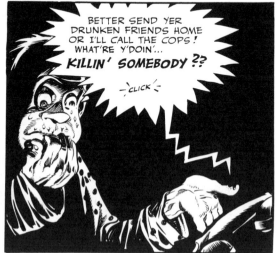

FIGURE 20: Ⓐ The initial rhythm is staccato. Ⓑ …followed by a large, stretched-out panel to convey a long ringing time.

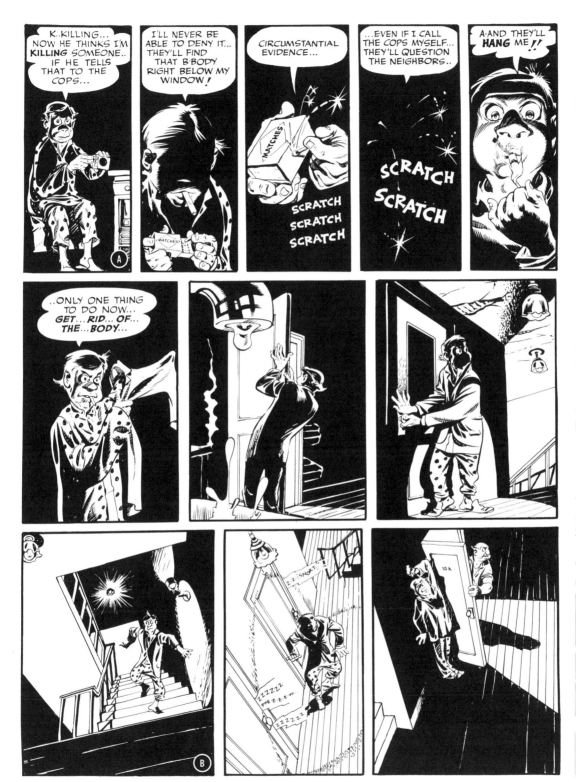

FIGURE 21: **Ⓐ** Now the pace quickens. Panels crowd each other. **Ⓑ** Perspective is altered to add time lapse without altering the rhythm.

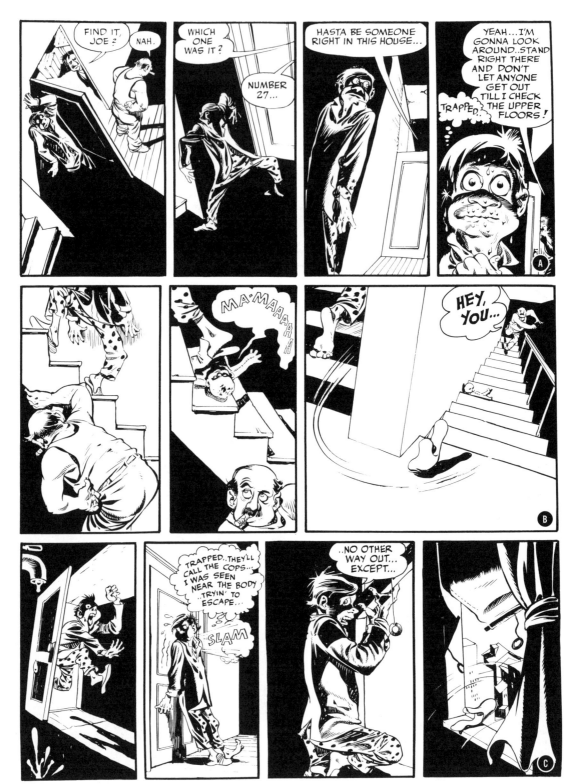

Comics and Sequential Art

FIGURE 22: Ⓐ The rhythm is maintained by the use of narrow panels of equal size. Ⓑ This is wider to permit the "beat" to pause a bit. Ⓒ Then the panel frequency resumes until the actor leaps through the window.

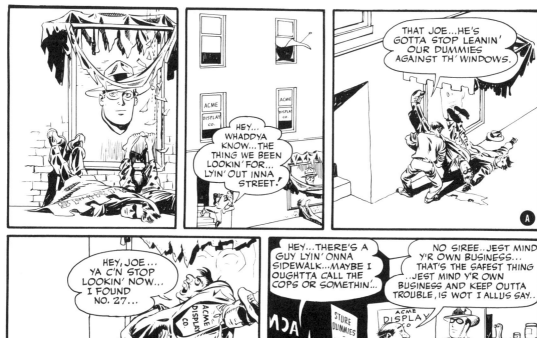

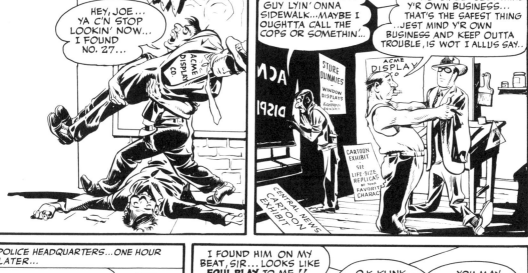

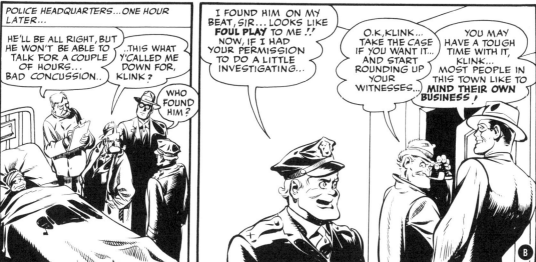

FIGURE 23: **A** Now the "beat" slows. Panels are more conventional. **B** The rhythm is slowed to a conventional pace. The story ends with a comfortable wide panel.

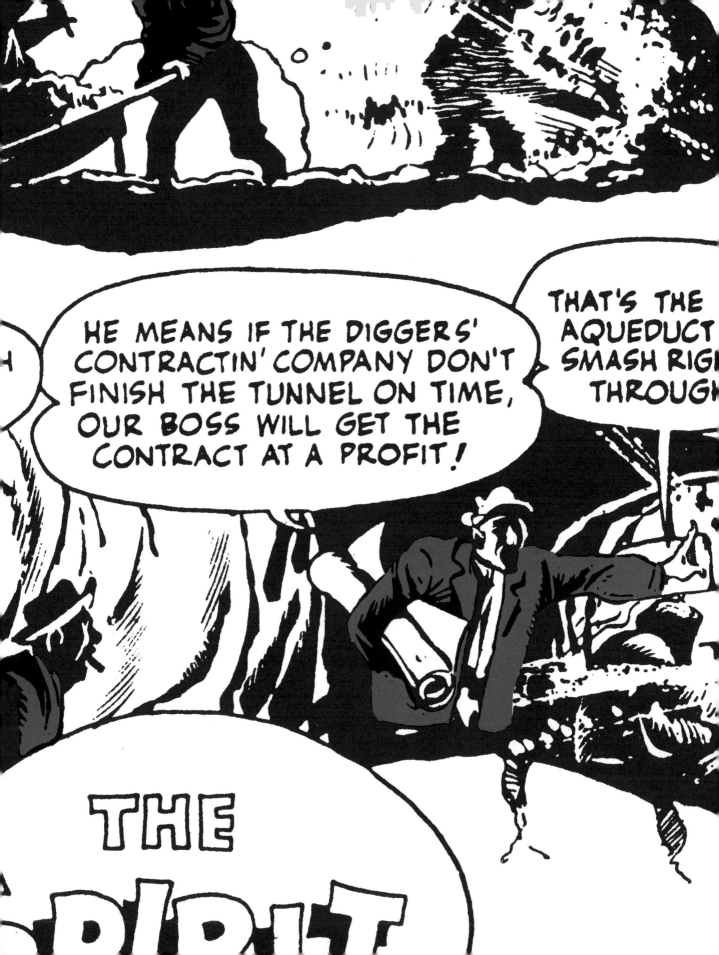

CHAPTER 4

THE FRAME

The fundamental function of comics art to communicate ideas and/ or stories by means of words and pictures involves the movement of certain images (such as people and things) through space. To deal with the *capture* or encapsulation of these events in the flow of the narrative, they must be broken up into sequenced segments. These segments are called panels or frames. They do not correspond exactly to cinematic frames. They are part of the creative process, rather than a result of the technology.

As in the use of panels to express the passage of time, the framing of a series of images moving through space undertakes the containment of thoughts, ideas, actions and location or site. The panel thereby attempts to deal with the broadest elements of dialogue: cognitive and perceptive as well as visual literacy. The artist, to be successful on this non-verbal level, must take into consideration both the commonality of human experience and the phenomenon of our perception of it, which seems to consist of frames or episodes.

If, as legendary magazine editor Norman Cousins points out, ". . . sequential thought is the most difficult work in the entire range of human effort," then the work of the sequential artist must be measured by comprehensibility. The sequential artist "sees" for the reader because it is inherent to narrative art that the requirement on the viewer is not so much analysis as recognition. The task then is to arrange the sequence of events (or pictures) so as to bridge the gaps in action. Given these, the reader may fill in the intervening events from experience. Success here stems from the artist's ability (usually more visceral than intellectual) to gauge the commonality of the reader's experience.

ENCAPSULATION

It should surprise no one that the limit of the human eye's peripheral vision is closely related to the panel as it is used by the artist to capture or "freeze" one segment in what is in reality an uninterrupted flow of action. To be sure, this seg-

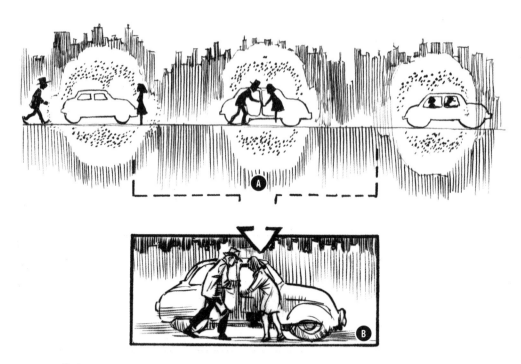

FIGURE 24: **A** The scene viewed through the reader's eyes... seen from inside the reader's head. **B** Final panel selected from sequence of action.

mentation is an arbitrary act—and it is in this encapsulation that the artist employs the skill of narration. The rendering of the elements within the frame, the arrangement of the images therein and their relation to and association with the other images in the sequence are the basic "grammar" from which the narrative is constructed.

In visual narration the task of the author/artist is to record a continued flow of experience and show it as it may be seen from the reader's eyes. This is done by arbitrarily breaking up the flow of uninterrupted experience into segments of "frozen" scenes and enclosing them by a frame or panel.

The total time elapsed in FIGURE 24 may be minutes in duration and the periphery of the stage very wide. Out of this, the position of the actors in relation to the scenery is selected, frozen and encapsulated by a panel frame. There is an unquestioned relationship here between what

the reader perceives as the flow of events and what is frozen in time by the panel.

THE PANEL AS A MEDIUM OF CONTROL

In sequential art the artist must, from the outset, secure control of the reader's attention and dictate the sequence in which the reader will follow the narrative. The limitations inherent in the technology of printed comics are both obstacle and asset in the attempt to accomplish this. The most important obstacle to surmount is the tendency of the reader's eye to wander. On any given page, for example, there is absolutely no way in which the artist can prevent the reading of the last panel before the first. The turning of the page does mechanically enforce some control, but hardly as absolutely as in film.

ABOVE: The viewer sees (reads) a film only one frame at a time. He cannot see the next (or past) frames until they are projected by the machine.

The viewer of a film is prevented from seeing the next frame before the creator permits it because these frames, printed on strips of transparent film, are shown one at a time. So film, which is an extension of comic strips, enjoys absolute control of its "reading"—an advantage shared by live theater. In a closed theater the proscenium arch and the wings of the stage can form but one single panel, while the audience sits in a fixed position from which they view the action contained therein.

THE MOST IMPORTANT OBSTACLE TO SURMOUNT IS THE TENDENCY OF THE READER'S EYE TO WANDER.

It is true that in the realm of digital comics (comics published and distributed on the Internet) a sequential artist can control timing and flow of the story in a larger number of ways than in printed comics. In addition to a panel-by-panel progression or pre-programmed slideshow that mimic the way printed comics have traditionally been read, an artist can take advantage of Webpages' ability to scroll, keeping later action out of sight, and giving the artist a panel of potentially limitless size which can be moved in any direction.

Still, even given these technical advantages, in all forms of comics the sequential artist relies upon the tacit cooperation of the reader. This cooperation is based upon the convention of reading (left to right, top to bottom, etc.) and the common cognitive disciplines. Indeed, it is this very voluntary cooperation, so unique to comics, that underlies the contract between artist and audience.

In comics, there are actually two "frames": the total page (or screen, in digital comics), on which there are any number of panels, and the panel itself, within which the narrative action unfolds. They are the controlling devices in sequential art.

The (Western culture) reader is trained to read each page independently from left to right, top to bottom. Panel arrangements on the page assume this (see FIGURE 25). In Japanese *manga*, the opposite reading sequence is employed, and most translations of Japanese comics retain this right-to-left configuration.

One of these arrangements, then, is ideally the normal flow of the reader's eye. In practice, however, this discipline is not absolute. The viewer will

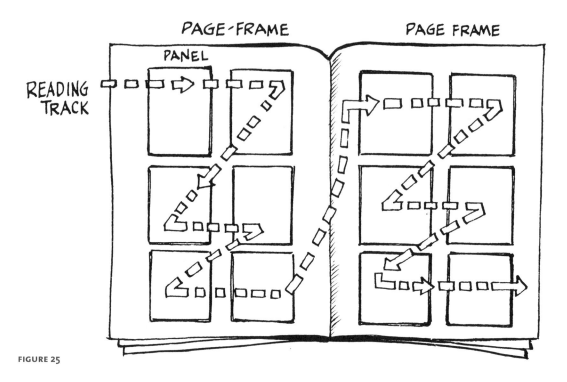

PAGE-FRAME

PAGE FRAME

PANEL

READING TRACK

FIGURE 25

often glance at the last panel first. Nevertheless, the reader finally must return to the conventional pattern.

CREATING THE PANEL

In the main, the creation of the frame begins with the selection of the elements necessary to the narration, the choice of a perspective from which the reader is allowed to see them, and the determination of the portion of each symbol or element to be included in the frame. Each panel is thus executed with respect to design and composition, as well as its narrative consequence. Much of this is done with the emotion or intuitiveness embodied in the artist's "style." The understanding of the reader's visual literacy, however, is an intellectual matter. A very simple example of this is shown in the "panelization" of a single figure (see FIGURE 26).

When the full figure is shown (A), no sophistication is required of the reader. The entire image is complete and intact. In panel (B) the reader is expected to understand that the figure shown has legs in proper proportion to the torso and that they are in a compatible position. In the close-up (C), the reader must supply the rest of the picture in conformity with what the physiology of the head suggests.

In a given series of panels wherein the frame encompasses only the head, a "visual dialogue" occurs between the reader and the artist which requires certain assumptions growing out of a common level of experience (see FIGURE 27).

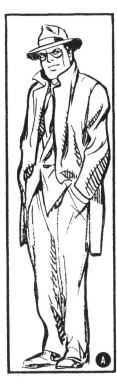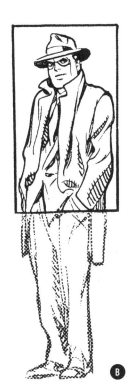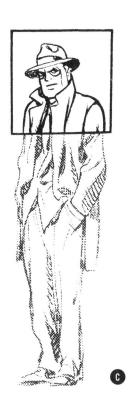

FIGURE 26: **Ⓐ** FULL FIGURE—The figure shown in full. It asks nothing of the reader's imagination or knowledge. **Ⓑ** MEDIUM—The reader is expected to supply the rest of the image—given a generous hint of the anatomy. **Ⓒ** CLOSE-UP—The reader is expected to assume that the entire figure exists and to deduce out of memory and experience the posture and detail.

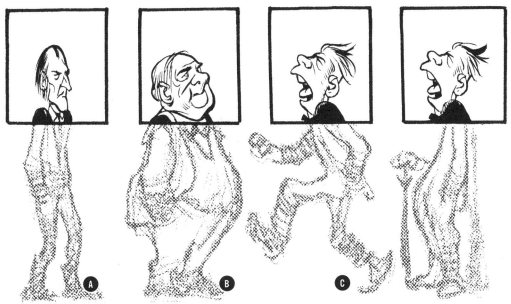

FIGURE 27: **Ⓐ** The slim head implies a slim body. **Ⓑ** The fat head implies a fat body. Subsequent views of the characters will of course substantiate these assumptions. **Ⓒ** This illustration, however, serves to demonstrate that there can be a misreading of the artist's intentions unless a more skilled drawing is executed in the panel itself or a prior panel has established what it is the reader is viewing.

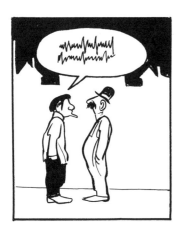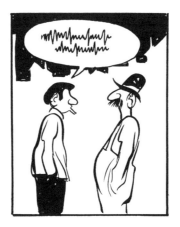

FIGURE 28

THE PANEL AS A CONTAINER

The most basic panel layout is one in which both the shape and proportion of the box remain rigid. The panels act to contain the reader's view, nothing more. This type of "panelization" is more commonly seen in comic strips than in comic books or digital comics because it is a natural extension of the format requirements of the newspapers in which they appear (see FIGURE 28).

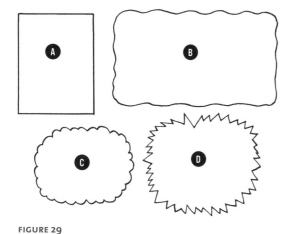

FIGURE 29

THE "LANGUAGE" OF THE PANEL BORDER

In addition to its primary function as a frame in which to place objects and actions, the panel border itself can be used as part of the non-verbal "language" of sequential art.

For example (see FIGURE 29), rectangular panels with straight-edged borders (A), unless the verbal portion of the narrative contradicts this, usually are meant to imply that the actions contained therein are set in the present tense. Flashbacks—a change in tense or shift in time—are often indicated by altering the line which makes up the frame. The wavy-edged (B) or scalloped (C) panel border is the most common past time indicator. While there is no universally agreed upon convention for expressing tense through the outline of the frame, the "character" of the line—as in the case of sound, emotion (D) or thought (C)—creates a hieroglyphic.

The non-frame speaks to unlimited space. It has the effect of encompassing unseen but acknowledged background. The following from a *Spirit* story, "The Tragedy of Merry Andrew" (first published February 15, 1948), is an example of this (see FIGURE 30).

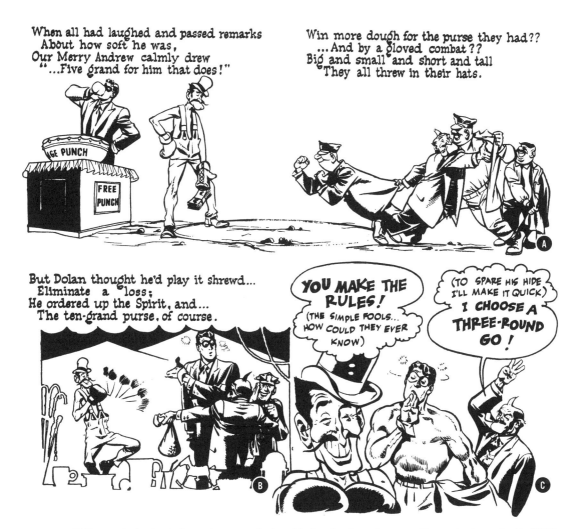

When all had laughed and passed remarks
About how soft he was,
Our Merry Andrew calmly drew
"...Five grand for him that does!"

Win more dough for the purse they had??
...And by a gloved combat??
Big and small and short and tall
They all threw in their hats.

But Dolan thought he'd play it shrewd...
Eliminate a 'loss;
He ordered up the Spirit, and...
The ten-grand purse, of course.

YOU MAKE THE RULES!
(THE SIMPLE FOOLS... HOW COULD THEY EVER KNOW)

(TO SPARE HIS HIDE I'LL MAKE IT QUICK)
I CHOOSE A THREE-ROUND GO!

FIGURE 30: ❶ The carnival set not shown here was displayed in the story's earlier pages. The reader is required to "fill it in" now. On this page the open panels are intended to imply unlimited space and the suggested setting. ❷ The use of a structural frame for this panel reinforces the reader's memory of the setting. ❸ And with a return to a non-frame, the reader again supplies the background.

THE FRAME AS A NARRATIVE DEVICE

A frame's shape (or the absence of one) gives it the ability to become more than just a proscenium through which a comic's action is seen: it can become a part of the story itself. It can be used to convey something of the dimension of sound and emotional climate in which the action occurs, as well as contributing to the atmosphere of the page as a whole. The intent of the frame here is not so much to provide a stage as to heighten the reader's involvement with the narrative, much like a play in which actors interact with the audience, rather than merely performing in front of it.

"THE TASK THEN IS TO ARRANGE THE SEQUENCE OF EVENTS (OR PICTURES) SO AS TO BRIDGE THE GAPS IN ACTION. GIVEN THESE, THE READER MAY FILL IN THE INTERVENING EVENTS FROM EXPERIENCE."

R. CRUMB, ANOTHER MASTER OF CARTOONING, brilliantly uses the frame to tell a story. In this case, the story is not about an individual but America itself.

In "A Short History of America," the gaps between Crumb's panels aren't minutes or hours but years (if not decades!). The panel frames a single corner with a consistent shot throughout the entire twelve-panel sequence. This emphasizes the changes within the panel itself so the transition from pastoral to urban is crystal clear. The deliberate framing of this comic perfectly demonstrates "a continued flow of experience and show it as it may be seen from the reader's eye."

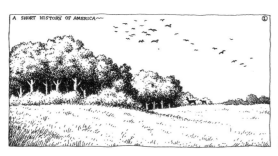
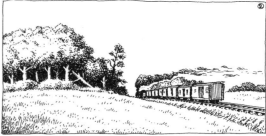

Whereas the conventional container-frame keeps the reader at bay—or out of the picture, so to speak—the frame as used in the examples below invites the reader into the action or allows the action to "explode" toward the reader (see FIGURES 31 through 36). In addition to adding a secondary intellectual level to the narrative, it tries to involve sensory dimensions beyond sight.

In FIGURE 37, a one-page segment from a *Spirit* story, "The Explorer" (first published January 16, 1949), the shape of the panel and even its rendering (such as a heavy versus a light outline) seek to deal with distance from the front of the stage. As in the theater, we are dealing with actions that are taking place on two tracks of time.

In dealing with concurrent actions the formal (heavy outline) panel is used to contain the "now" action and the non-outline serves to contain the "meanwhile."

FIGURE 31: The jagged outline implies an emotionally explosive action. It conveys a state of tension and is related to crisp crackle associated with radio or telephonic transmission of sound.

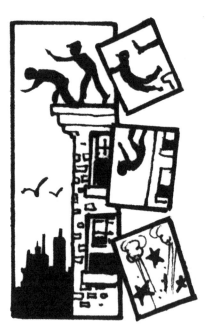

FIGURE 32: The long panel reinforces the illusion of height. The positioning of several square panels emulates a falling motion.

FIGURE 33: The illusion of power and threat is displayed by allowing the actor to burst out of the confines of the panel. Since the panel border is assumed to be inviolate in a comic page, this adds to the sense of unleashed action.

FIGURE 34: The absence of a panel outline is designed to convey unlimited space. It provides a sense of serenity and supports the narrative by contributing atmosphere to the narrative.

FIGURE 35: The "panel" here is actually the doorway. It tells the reader visually that the actor is confined in a small area within a wider one—the building.

FIGURE 36: The cloudlike enclosure defines the picture as being a thought or memory. The action would be read as actually taking place if there were no panel or a hard outline.

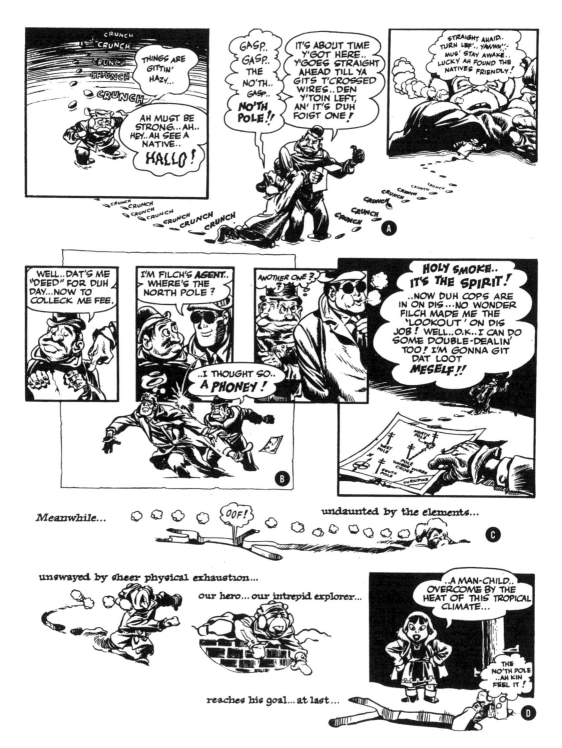

FIGURE 37: **Ⓐ** The illusion of unlimited space is demonstrated by the elimination of a panel outline. **Ⓑ** Three small panels contained by a thick outline superimposed over a broader panel with a thin outline are meant to convey a time-focus necessary to the narrative. **Ⓒ** The absence of a panel outline here narrates the duration of time and the limitless locale critical to the story. **Ⓓ** The hard outline of the last frame announces the close of the sequence.

THE FRAME AS A STRUCTURAL SUPPORT

In FIGURES 38 through 40 the frame's outline becomes part of the apparatus for suggesting three-dimensionality. The use of the panel border as a structural element within the setting that is portrayed, when so employed, serves to involve the reader and encompasses far more than a simple container-panel. The sheer novelty of the interplay between the contained space and the "non-space" (the gutter) between the panels also conveys a sense of heightened significance within the narrative structure.

FIGURE 38: Examples of doorways or windows serving as story panels. While functioning as panels, each is nevertheless also a structure in the setting of the story.

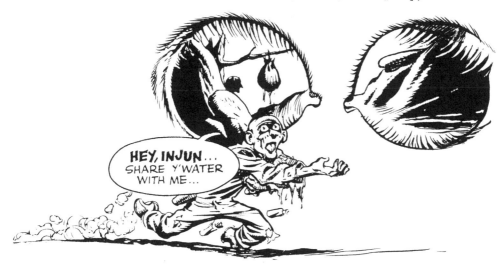

FIGURE 39: The normal "gutter" (space between panels) is actually expanded here to convey open "desert," while the outline of eyes as seen from inside the head serve as panels.

FIGURE 40: In this extract from the *Spirit* story "The Tunnel" (first published March 21, 1948), the "non-space" between the panels is literally the ground from which they are formed.

IMAGE THE PANEL OUTLINE

The range of possibility of outline is limited only to the requirements of the narrative and the constrictions of the page dimensions. Because the function of the panel outline is in service of the story it is actually created after, or in response to, the action determined by the author/artist.

FIGURE 41 shows a series of panel outlines freed of their internal images. They were employed in the following *Spirit* story, "The Amulet of Osiris" (November 28, 1948), as narrative devices (see FIGURES 42 through 48).

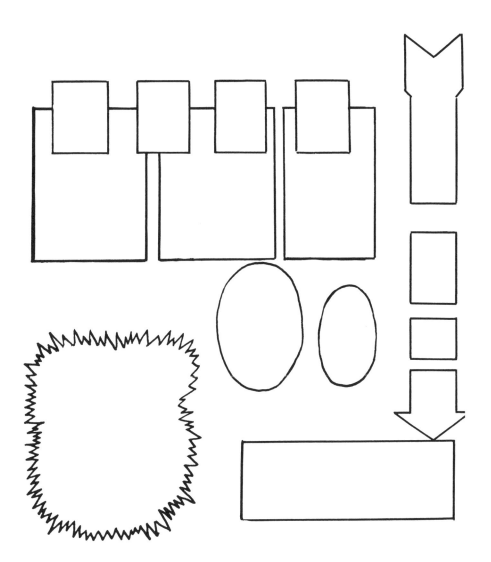

FIGURE 41

FIGURE 42: The arrangement of panel outlines and shapes on this page is devised to deal with the problem of reader discipline. The rhythm of the narrative is set in this manner. **Ⓐ** This panel device is meant to direct the reader's eye toward the next panel as it relates events. **Ⓑ** Here, the placement of a head, freed but relating to the narrow flat panel, evokes a feeling of a page that has unlimited dimensions.

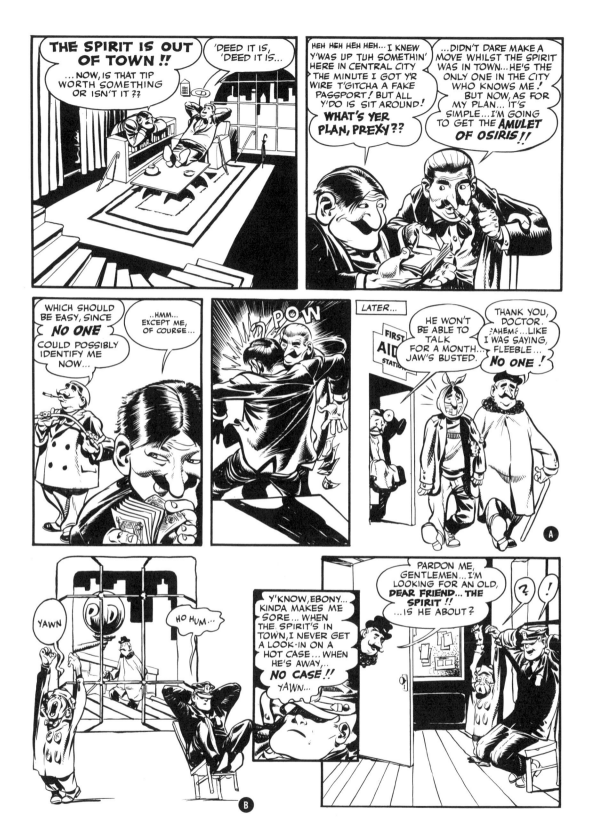

FIGURE 43: Ⓐ The doorway is the container in the panel. Ⓑ The panel outline is actually the window frame. This is an integral piece of background art that tells of a shift in location.

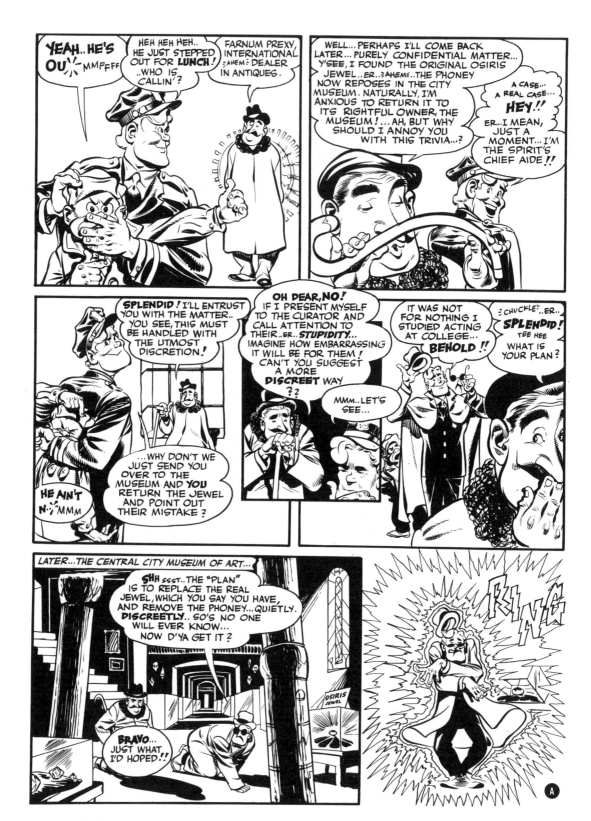

FIGURE 44: Ⓐ The panel is outlined by an "electric shock" simulation, which serves the narrative.

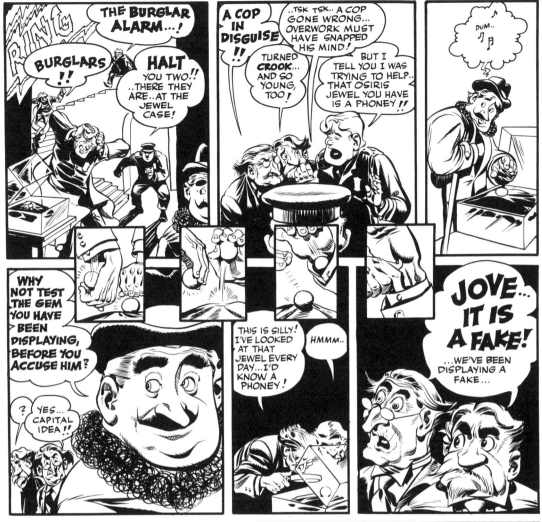

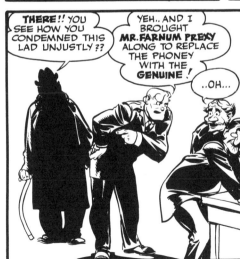

FIGURE 45

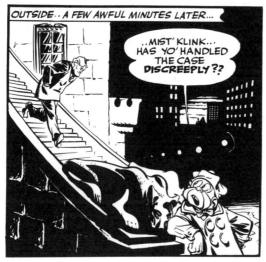

FIGURE 46: **A** An open panel that narrates space, time and location.

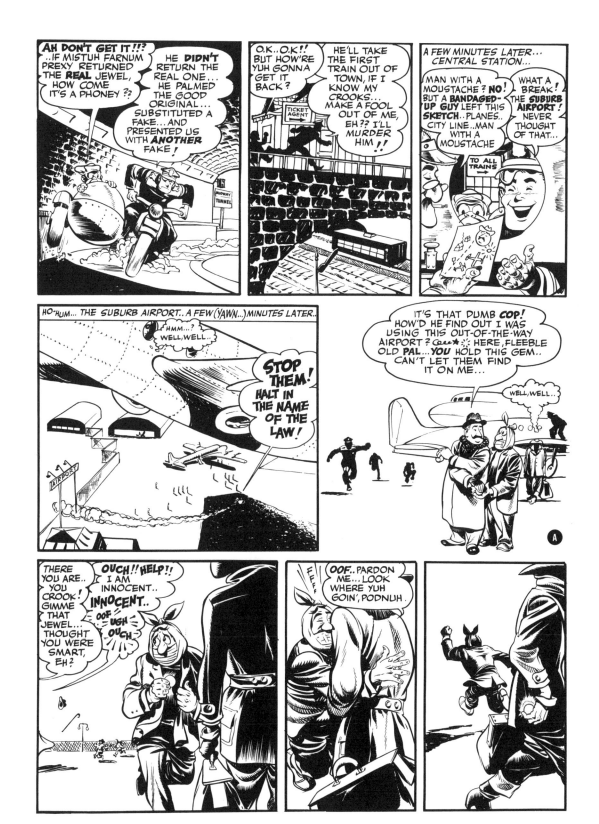

FIGURE 47: **Ⓐ** The use of an open panel here suggests the dimensions of the airfield.

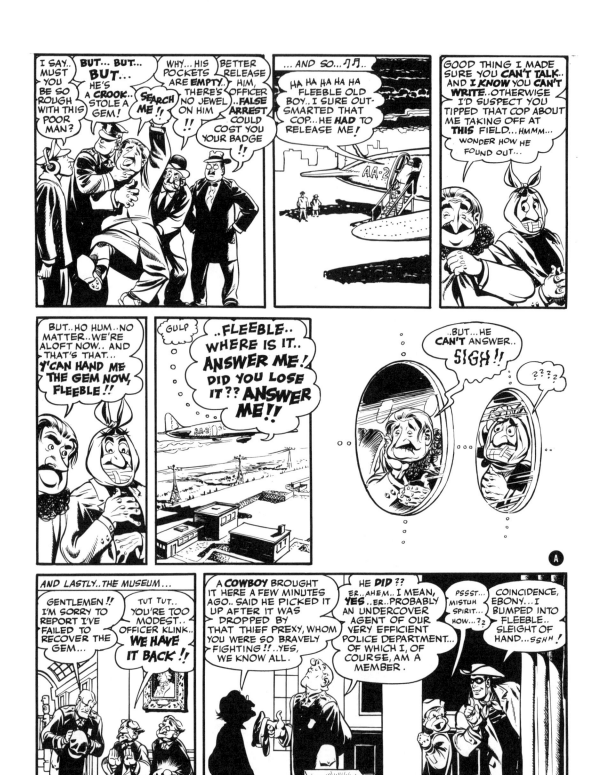

FIGURE 48: Ⓐ The portholes are designed to also serve as panel outlines.

The shape and treatment of the frames in the following three examples (see FIGURES 49 through 51) deal with the viewer's emotions. They make an effort to generate the reader's own reaction to the action and thus heighten emotional involvement in the narrative.

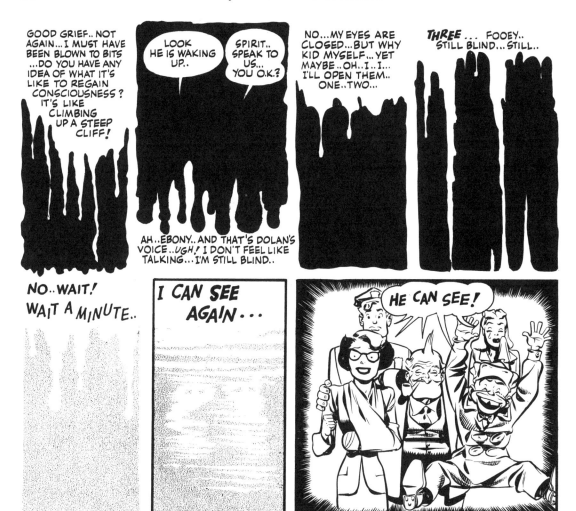

FIGURE 49: In the sequence dealing with the Spirit's recovery from blindness, the view is actually from inside the protagonist's eyes. The panel outline speaks to this and hopefully enables the reader to share in the experience. From the *Spirit* story "Fluid X" (first published September 14, 1947).

FIGURE 50: In this segment from the *Spirit* story "Deadline" (first published December 31, 1950), the rippled edges of the panel and its oblong shape intends uncertainty and impending danger. It is directed at the reader's sense of "feel."

BENEATH THE CITY SIDEWALKS, FAR BELOW THE FOOTSTEPS OF THE PEDESTRIANS, THROBS THE VAST NETWORK OF MOVING STEEL, CALL-ED THE SUBWAY.

FOR ENDLESS HOURS, DAY AND NIGHT, THE BIG CARS TRAVEL OVER THE MILES OF TRACK SWALLOWING AND DISCHARGE-ING HUMAN CARGO ON THEIR WAY TO WORK OR PLAY. . . .

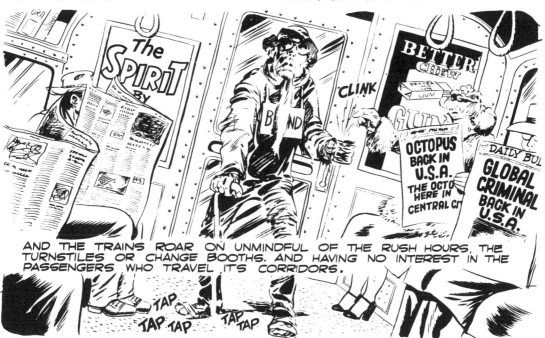

AND THE TRAINS ROAR ON UNMINDFUL OF THE RUSH HOURS, THE TURNSTILES OR CHANGE BOOTHS. AND HAVING NO INTEREST IN THE PASSENGERS WHO TRAVEL ITS CORRIDORS.

FIGURE 51: This treatment from a *Spirit* story, "The Octopus Is Back" (first published February 11, 1951), is set on a subway where the rocking of the train is meant to be "felt" by the reader. Titling of panels and lettering seeks to create a sublim-inal jarring effect.

THE SPLASH PAGE

The first page of a story functions as an introduction (see FIGURE 52). What, or how much, it contains depends on the number of pages that follow. It is a launching pad for the narrative, and for most stories it establishes a frame of reference.

Properly employed it seizes the reader's attention and prepares his attitude for the events to follow. It sets a "climate." It becomes a splash page proper rather than a simple first page when the artist designs it as a decorative unit.

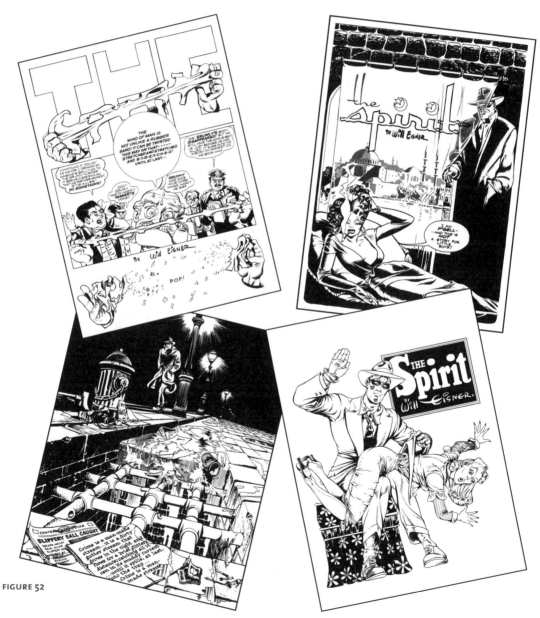

FIGURE 52

In the following chapter from *Life on Another Planet* (1980) the panel is subordinated to the totality of the narrative. The panel is, in the conventional configuration, used only sparingly. A synthesis of speed, multi-leveled action, narrative and the dimensions of the stage is the attempted goal.

The challenge here is to employ the panel so that it will not intrude on the segment of the story encompassed by the page frame. Thus for most of the story, the "hard-frame" is not the individual panel but the total page.

PAGES ARE THE CONSTANT IN COMIC BOOK NARRATION. THEY HAVE TO BE DEALT WITH IMMEDIATELY AFTER THE STORY IS SOLIDIFIED.

Where the actors are displaying powerful and sophisticated emotions—where their postures and gestures are subtle and critical to the telling of the story—the panel outlines become a liability unless imposed with concern for their effect on what they contain.

One important facet of the full-page frame (here called a meta-panel, or super-panel) is that planning the breakdown of the plot and action into page segments becomes the first order of business. Pages are the constant in comic book narration. They have to be dealt with immediately after the story is solidified. Because the groupings of action and other events do not necessarily break up evenly, some pages must contain more individual scenes than others. Keep in mind that when the reader turns the page a pause occurs. This permits a change of time, a shift of scene, an opportunity to control the reader's focus. Here one deals with retention as well as attention. The page as well as the panel must therefore be addressed as a unit of containment although it, too, is merely a part of the whole comprised by the story itself. This is no less true of comics presented digitally—the sequential artist must take into consideration the use of meta-panels of page, browser, and screen.

In the following example (see FIGURES 52 to 68), each page is of unequal reading duration, time and rhythm. Each encompasses a different time and setting. Each page is a result of careful deliberation. Note that there was no intention to create "page interest" at the cost of subordinating the internal (storytelling) panels. I would ordain, as a general rule: *What goes on INSIDE the panel is PRIMARY!*

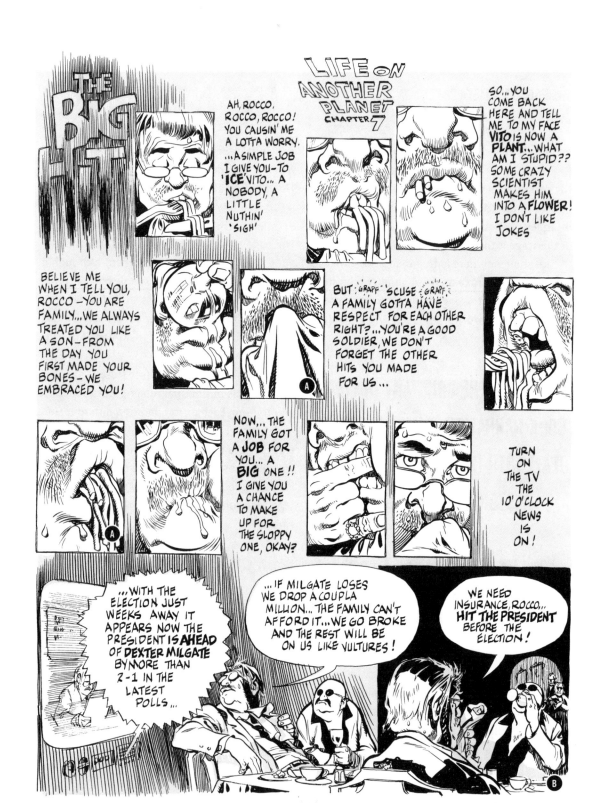

FIGURE 53: The entire page serves as a super-panel and as a splash page at the same time. The individual panels vary from small close-ups set on another plane to the overriding panel at the bottom. **Ⓐ** The small panels float above and in front of the plane on which this larger panel is set. **Ⓑ** These panels are the main action panels.

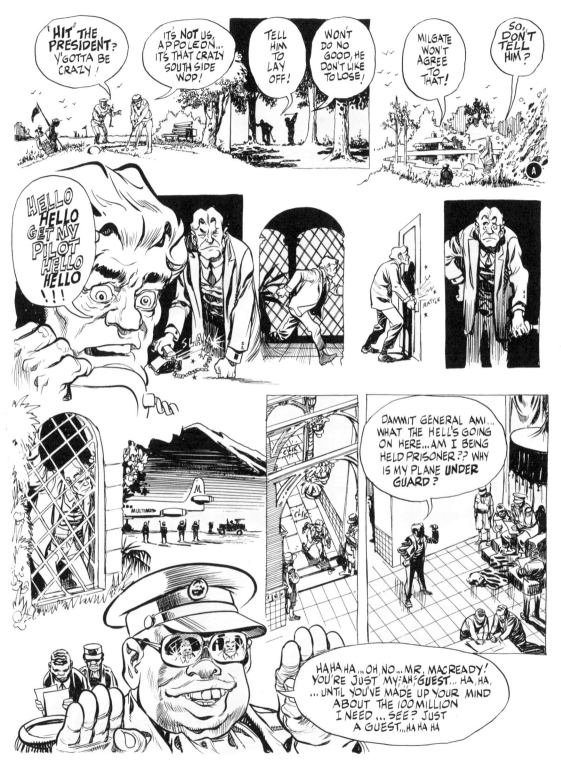

FIGURE 54: On this page a set of events not necessarily concurrent or in sequence must be held together because the threads of the plot are meant to be separate but related. **Ⓐ** The event on the top tier occurs in a different time and place from the sequence below, which occurs in a more confined environment.

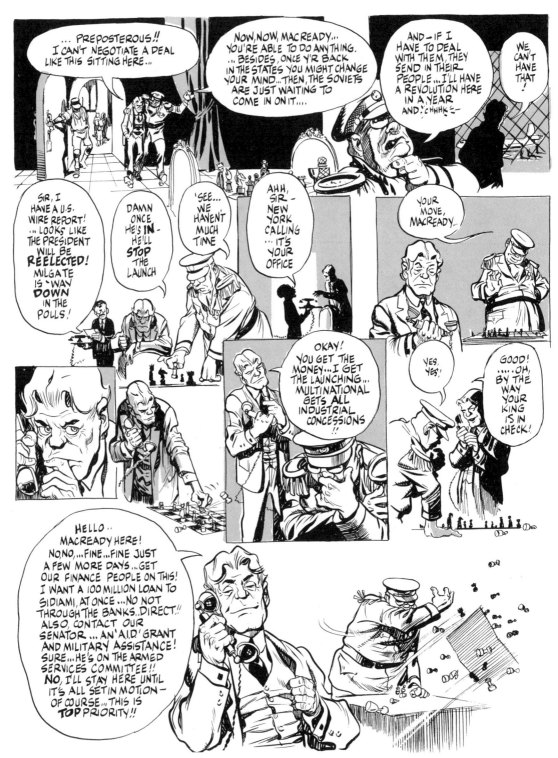

68

FIGURE 55: On this page the super-panel contains a sequence of short duration. In reality it is a single unit that concludes the action begun on the previous page.

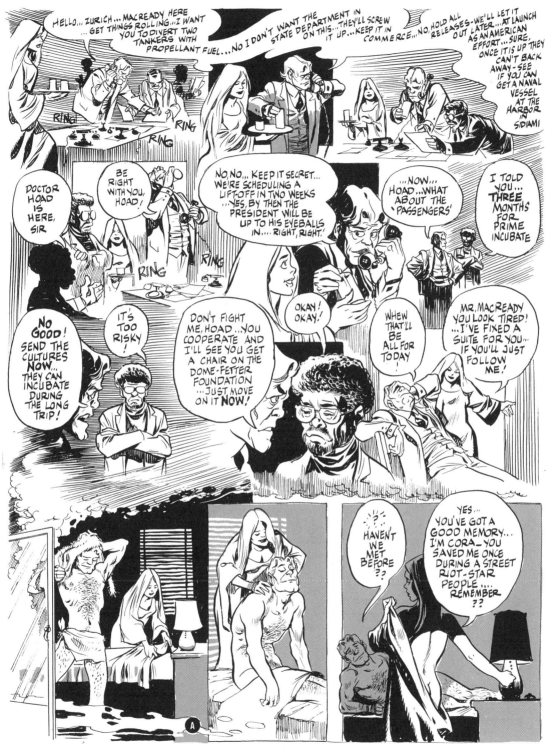

69

FIGURE 56: This page holds the reader in place while it permits a series of actions, which have flexible time frame. It is not a flashback or "thought" panel. It simply accelerates the narrative. **Ⓐ** This panel employs the steam from the shower as a connecting device and employs the super-panel of the page to slow down the rate of narration.

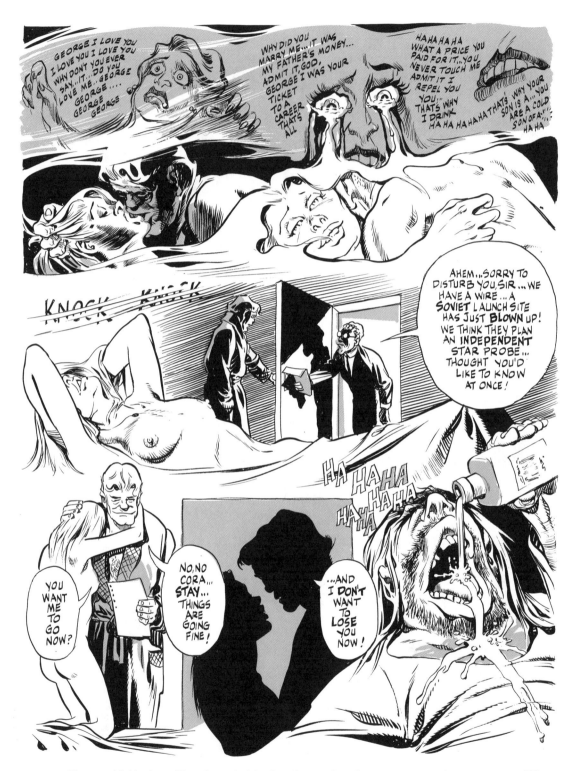

FIGURE 57: The man drinking is positioned so as to introduce the panel on the next page. It seeks to separate itself from the page unit, leaving the integrity of the page intact.

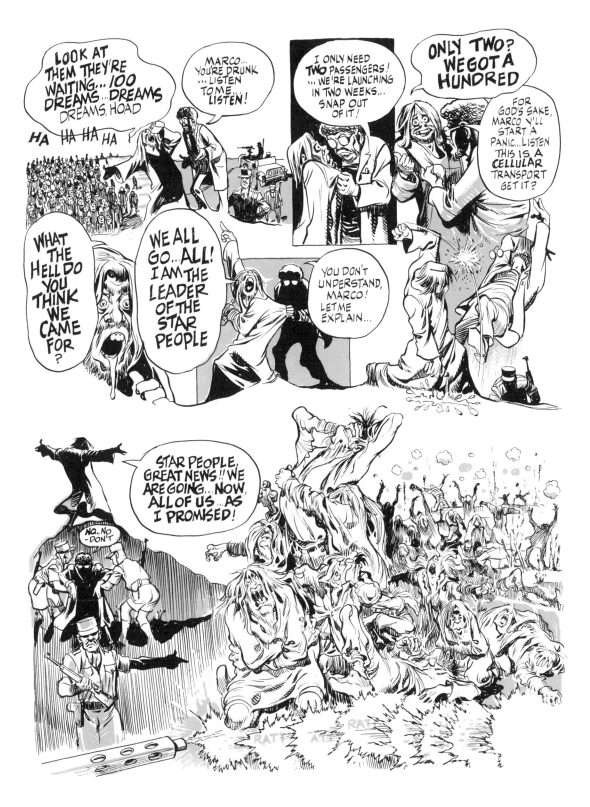

FIGURE 58: Because of the fluidity of the action and the amorphous quality of the setting the page is, at first glance, read as a single panel. The dominance of the art at the bottom ordains this.

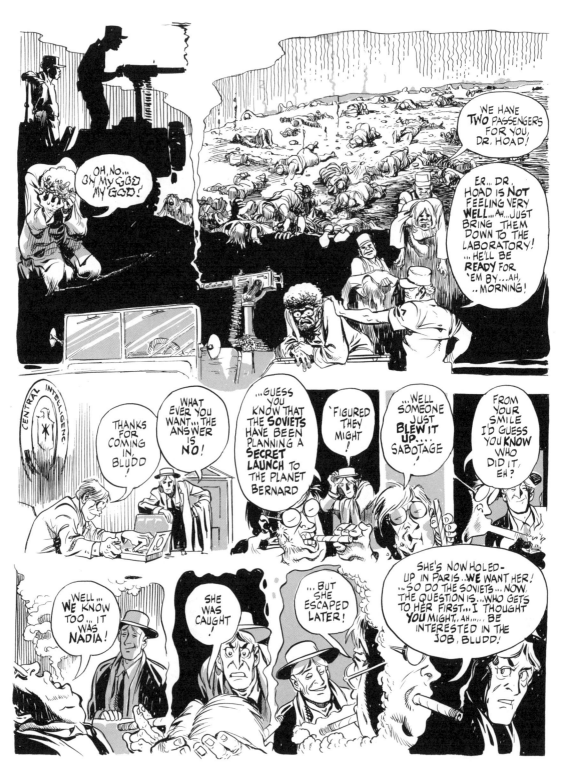

FIGURE 59: The page, acting as container, permits the upper half to conclude the action of the previous page while the two tiers on the lower half dominate. Because of this, the page is seen as two units, each within a fixed site.

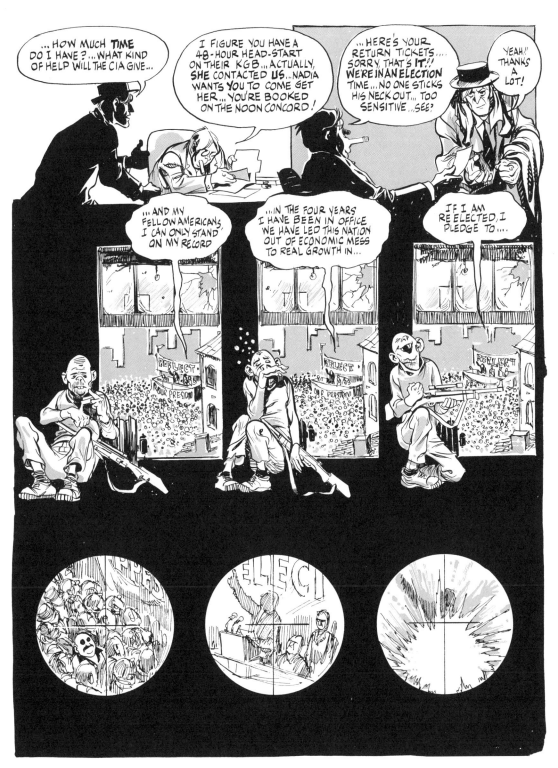

FIGURE 60: Here, as on earlier pages, time and location are juxtaposed so that the page is first seen in totality. The details of action are the weave in the fabric.

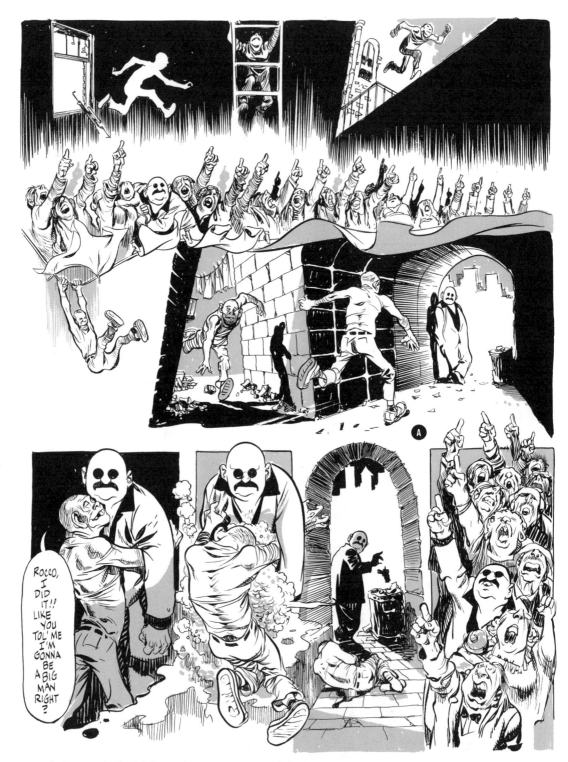

FIGURE 61: Once again the total page functions to set mood, rhythm and climate. This is especially useful when there is fast-paced activity. Ⓐ To deal with the ballet-like movement of the fugitive, the single background is used as a device to support two panels.

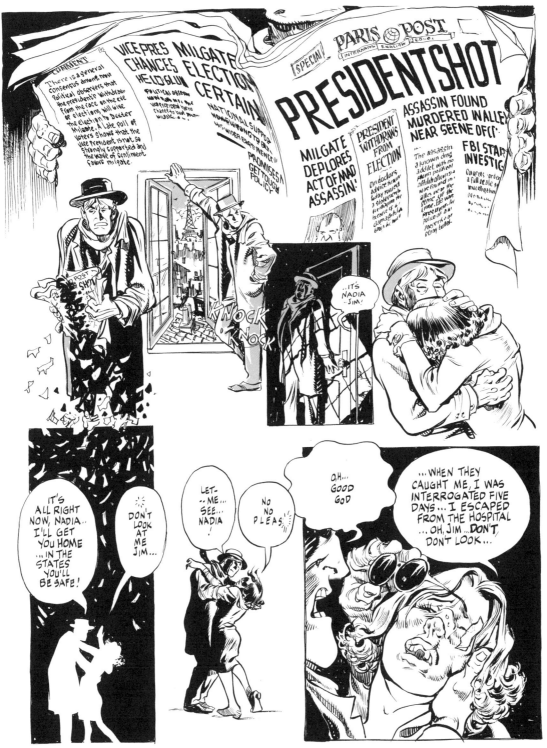

FIGURE 62: With an overriding background narrative such as the newspaper story, the page becomes a sub- or underlying panel by acting as an extension of the newspaper itself.

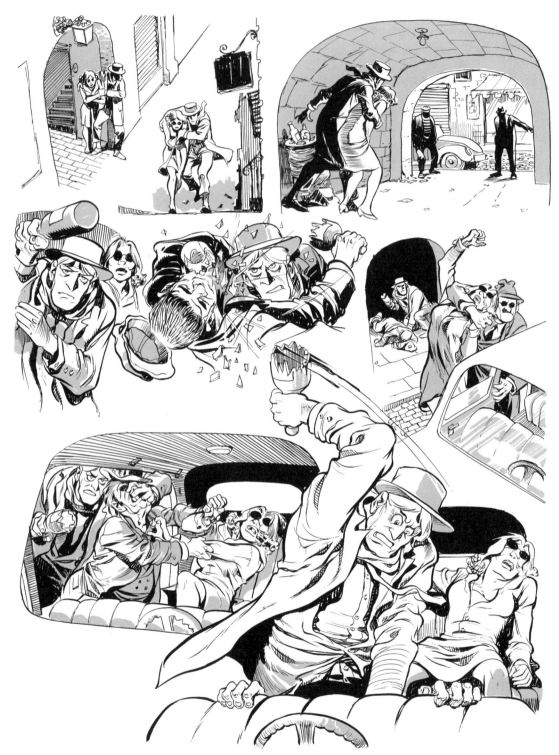

FIGURE 63: Another example where the page is to be a panel containing the major statement: the hero attacking the kidnapper. The rest are sub-panels to background.

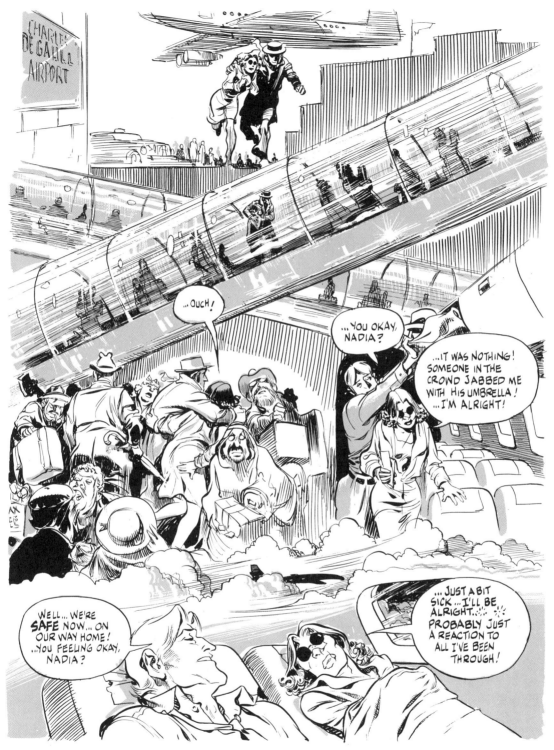

FIGURE 64: This page attempts to deal with a major problem in a swiftly moving narrative. Within the broad action of an escape a critically important detail (the stabbing of the girl with an umbrella) is centered on the page. It is the best solution because it must have enough emphasis to lodge itself in the reader's memory. Obviously the girl's hand helps to convey the brief pain.

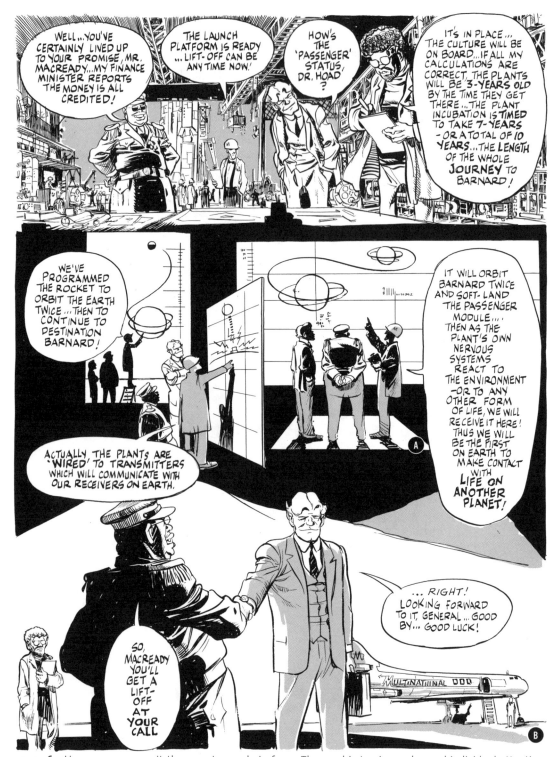

FIGURE 65: Here, one can permit the page to recede in focus. The need is to give each panel individual attention. **Ⓐ** Isolating the sky-map makes it usable as a panel, which adds time to the sequence. **Ⓑ** Only the last scene employs the page as a super-panel.

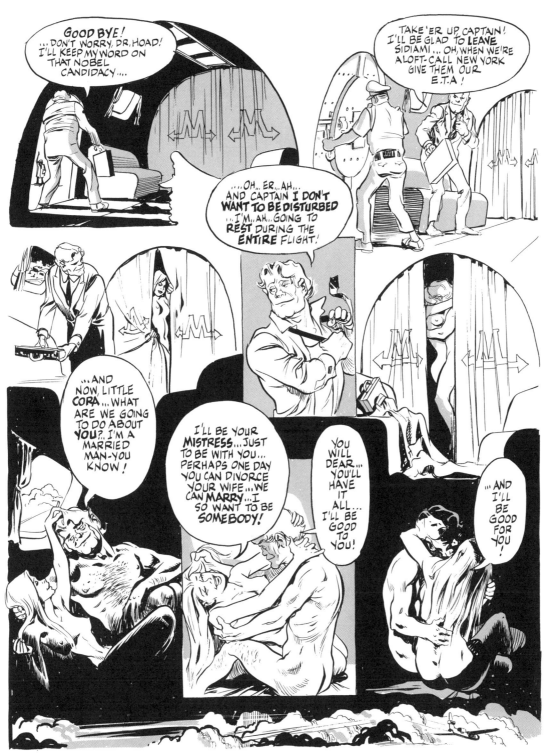

FIGURE 66: This page continues to serve as a single-sequence container, thereby becoming a unit. In effect it is a meta-panel—part of the whole chapter.

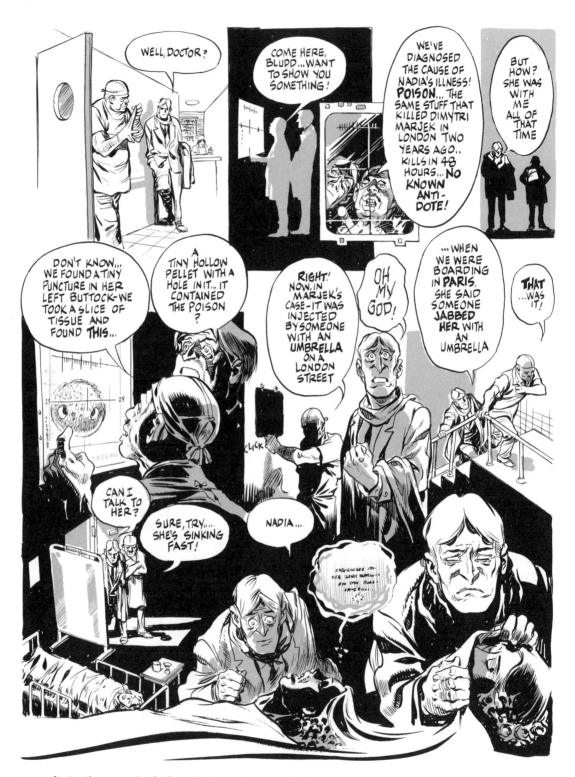

FIGURE 67: Another example of a flow of action gathered and held by the open panel below.

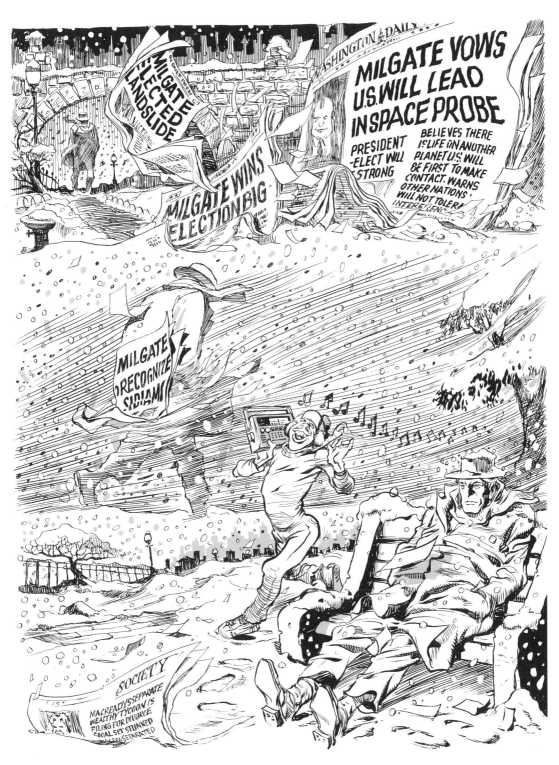

FIGURE 68: This last page I designed to be swallowed whole. That is, I hoped the reader would see and feel the entire page as a panel, then, steeped in the mood or message, read the newspapers, which give the action depth.

IMAGE THE SUPER-PANEL AS A PAGE

Where the super-panel purports to be a page—that is, to make the reader conscious of it as a page—it serves as a containment without perimeter. It is best employed for parallel narratives.

This narrative form, or device, has interesting potential not often explored in comics. The printed form lends itself to this because, unlike the transitory nature of film, it can be referred to repeatedly throughout the reading. Obviously, it depends on the plot and careful planning.

In a plot where two independent narratives are shown simultaneously, the problem of giving them equal attention and weight is addressed by making the panel that controls the total narrative the entire page itself. The result, a set of panels within panels, attempts to control the reader's line of reading so that two storylines may be followed synchronously (see FIGURE 69).

In the following example from the *Spirit* story "Two Lives" (December 12, 1948), parallel development is both the solution of the problem of simultaneity and the actual theme of the plot itself (see FIGURES 70 through 76).

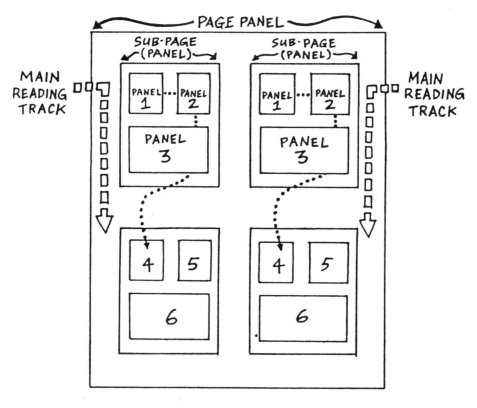

FIGURE 69: This diagram shows the reading track in such a device. Control of the reader's eye must be carefully considered.

FIGURE 70: In this story the perimeters of the total page—or any consciousness of it—disappear after first perusal. The reading track begins in the traditional manner. Each book is a visual device and a meta-panel at the same time.

FIGURE 71: The main reading track is vertical, but within each meta-panel it is traditional. After the left-hand side of the page is read, then the right-hand column is read. I designed the outline of each major panel as a book page, to ensure against confusion.

Comics and Sequential Art

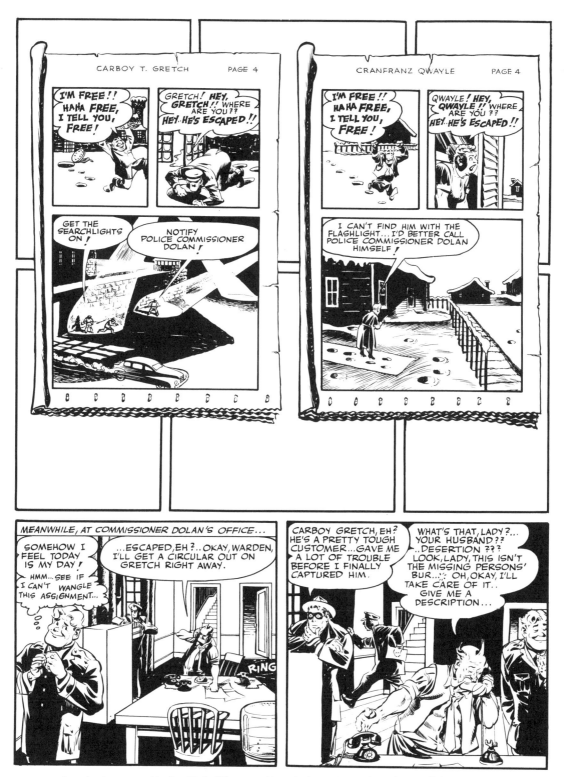

The Frame

FIGURE 72: In order to resume the "reality" of the page, I inserted empty panels under parallel pages. This device was intended to control the frame of reference.

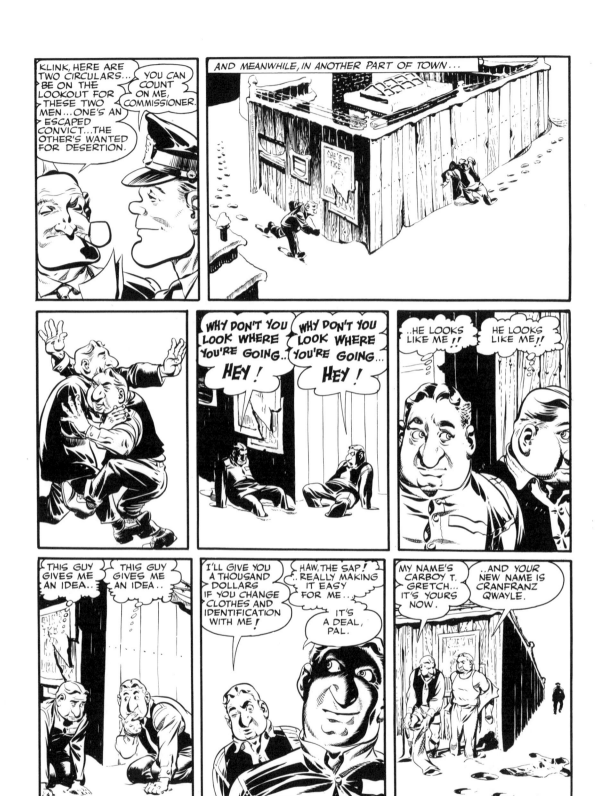

FIGURE 73: Here, the resumption of the normal single-page layout returns the focus to the present tense.

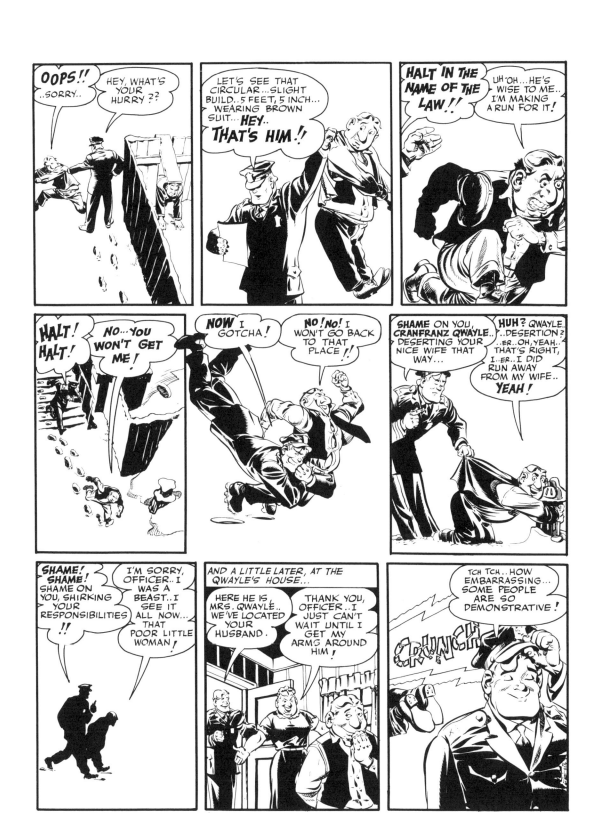

FIGURE 74: The story now flows as a single narrative with the action undivided.

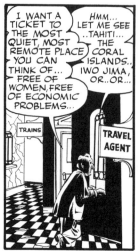
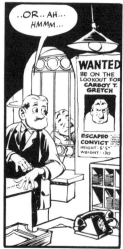
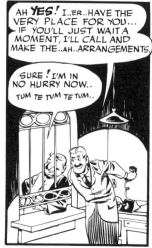
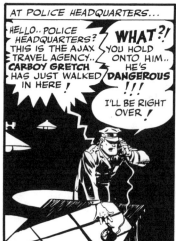
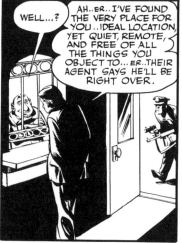
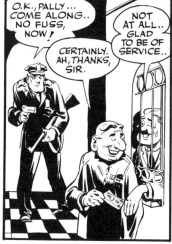
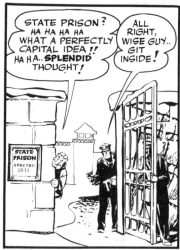
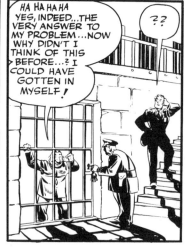
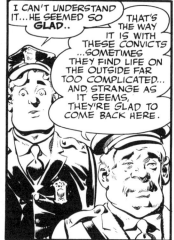

FIGURE 75: By now the reader is moving along through the story as he normally would.

Comics and Sequential Art

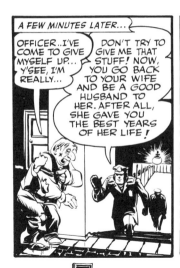
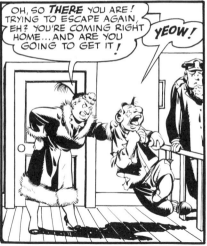
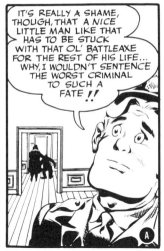

A FEW MINUTES LATER...

OFFICER..I'VE COME TO GIVE MYSELF UP... Y'SEE, I'M REALLY...

DON'T TRY TO GIVE ME THAT STUFF! NOW, YOU GO BACK TO YOUR WIFE AND BE A GOOD HUSBAND TO HER. AFTER ALL, SHE GAVE YOU THE BEST YEARS OF HER LIFE!

OH, SO *THERE* YOU ARE! TRYING TO ESCAPE AGAIN, EH? YOU'RE COMING RIGHT HOME...AND ARE YOU GOING TO GET IT!

YEOW!

IT'S REALLY A SHAME, THOUGH, THAT A *NICE* LITTLE MAN LIKE THAT HAS TO BE STUCK WITH THAT OL' BATTLEAXE FOR THE REST OF HIS LIFE... WHY, I WOULDN'T SENTENCE THE WORST CRIMINAL TO SUCH A FATE!!

ooo **A**ND SO...AS WE SAID...
WHO AMONG US CAN ACCURATELY SAY WHAT IS A FIT PUNISHMENT ??
OR...IN THE WORDS OF HIS IMPERIAL MAJESTY, GILBERT & SULLIVAN'S EARNEST MIKADO OF JAPAN...

♫ My object all sublime
 I shall achieve in time
To let the punishment fit the crime
 The punishment fit the crime...♫

CARBOY T. GRETCH PAGE 7

© 1966 WILL EISNER

CRANFRANZ QWAYLE PAGE 7

SOLITARY CONFINEMENT

FIGURE 76: Ⓐ This tier of panels acts as a bridge bringing the reader to a surprise ending. **Ⓑ** The parallel narrative is restored.

ABOVE: **Ⓐ** A center of interest is established. **Ⓑ** This becomes the site of the major action. **Ⓒ** The perspective is now determined. (Note: the center of interest is not altered.) **Ⓓ** The secondary narrative elements are added.

OPPOSITE: **Ⓐ** In this panel a flat, eye-level view informs the reader of details such as the commanding action of the soldier's hand. **Ⓑ** Here, an overhead view is employed to give the reader a clear, uninvolved view of the setting for the events to follow. **Ⓒ** Placing the reader on ground level provides a maximum impact explosion that can be "felt." **Ⓓ** In this panel the reader's perspective is lowered to a worm's-eye view for an ominous involvement in the action.

PANEL COMPOSITION

The composition of a comic strip panel is comparable to the planning of a mural, book illustration, easel painting or theatrical scene.

Once the flow of action is "framed" it becomes necessary to compose the panel. This involves perspective and the arrangement of all the elements. The prime considerations are serving the flow of narrative and following standard reading conventions. Concern with mood, emotion, action and timing follows. Decoration or novelty of arrangement come into play only after these are resolved.

Functioning as a stage, the panel controls the viewpoint of the reader; the panel's outline becomes the perimeter of the reader's vision and establishes the perspective from which the site of the action is viewed. This manipulation enables the artist to clarify activity, orient the reader and stimulate emotion.

The reader's "position" is assumed or predetermined by the artist. In each case the result is the view as the reader will see it.

READER'S VIEW →

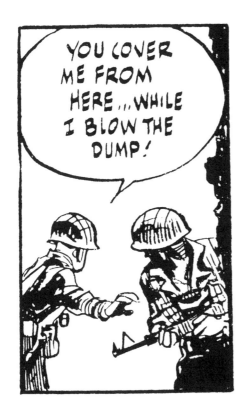

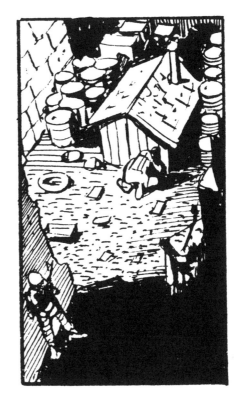

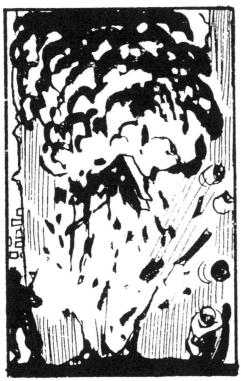

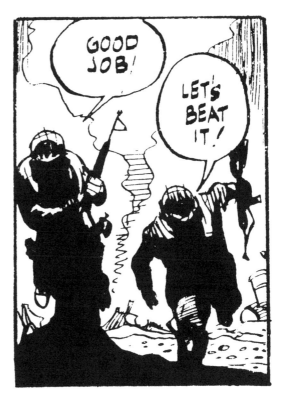

IMAGE THE FUNCTION OF PERSPECTIVE

The primary function of perspective should be to manipulate the reader's orientation for a purpose in accord with the author's narrative plan. For example, accurate perspective is most useful when the sense of the story requires that the reader know precisely where all the elements of a drama are in relation to each other.

Another use of perspective is its employment to manipulate and produce various emotional states in the reader. I proceed from the theory that the viewer's response to a given scene is influenced by his position as a spectator. Looking at a scene from above it, the viewer has a sense of detachment—he is an observer rather than a participant. However, when the reader views a scene from below it, then his position evokes a sense of smallness, which stimulates a sensation of fear. The shape of the panel in combination with perspective promotes these reactions because we are responsive to environment. A narrow panel evokes the feeling of being hemmed in—confinement; whereas a wide panel suggests plenty of space in which to move—or escape. These are deep-seated primitive feelings and work when used properly.

The shape of the panel and the use of perspective within it can be manipulated to produce various emotional states in the viewer.

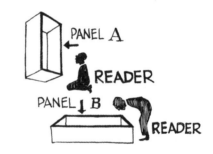

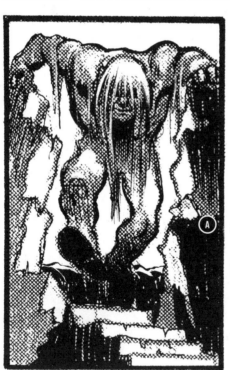

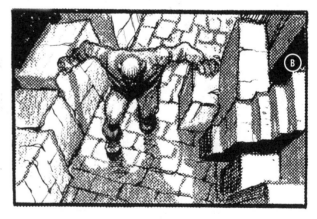

ABOVE: **Ⓐ** In this example the oblong shape of the panel combined with the worm's-eye view from below evokes a sense of threat. The reader feels confined and dominated by the monster. **Ⓑ** The same scene from a bird's-eye view and set in a wide panel stimulates the sense of detachment. The reader, with plenty of elbow room, is above it all. There is little threat or involvement.

In the main, comics are a representational art form devoted to the emulation of real experience. The author/artist, therefore, in the pursuit of reality must be constantly concerned with perspective. Often he is confronted with a choice between the design or impact of the page and art versus the needs of the story. I regard this as an inherent problem because the primary task of the comic magazine publisher is to issue a "package" that will be compelling at first glance to the buyer in the bookstore. As a result the integrity of the storytelling is compromised. Indeed, the artist himself becomes party to this subordination because the *first judgment* rendered onto any comic book work is centered on the artwork, style, quality and draftsmanship. It is, after all, a graphic medium. In a field where the writer and the artist are often two individuals whose professional reputations and earning power are dependent on recognition by the audience, the need for the artist to display artistic prowess even to the detriment of the story is quite irresistible. Often the result is an output of the story with virtuoso art work independent of—or even unrelated to—the story. A representative example of a genre that needs careful discipline in art and perspective is science fiction, which portrays supernatural occurrences in a realistic setting.

In the following *Spirit* story, "The Visitor" (February 13, 1949), the requirements of stagecraft demand a firm, head-on perspective throughout. This is for the purpose of increasing the sense of reality in what would otherwise be a fantasy plot (see FIGURES 77 through 83).

However, in a plot of this kind the temptation to go hog-wild with perspective shots and panel shapes is hard to resist. The carefully controlled and almost understated dissolve at the bottom of the last three panels on the story's last page is testimony to the discipline and restraint that is required to properly execute the surprise ending.

A REPRESENTATIVE EXAMPLE OF A GENRE THAT NEEDS CAREFUL DISCIPLINE IN ART AND PERSPECTIVE IS SCIENCE FICTION, WHICH PORTRAYS SUPERNATURAL OCCURRENCES IN A REALISTIC SETTING.

FIGURE 77: The graphic display on the page sets the mood. It creates a climate that promises a supernatural or science fiction theme.

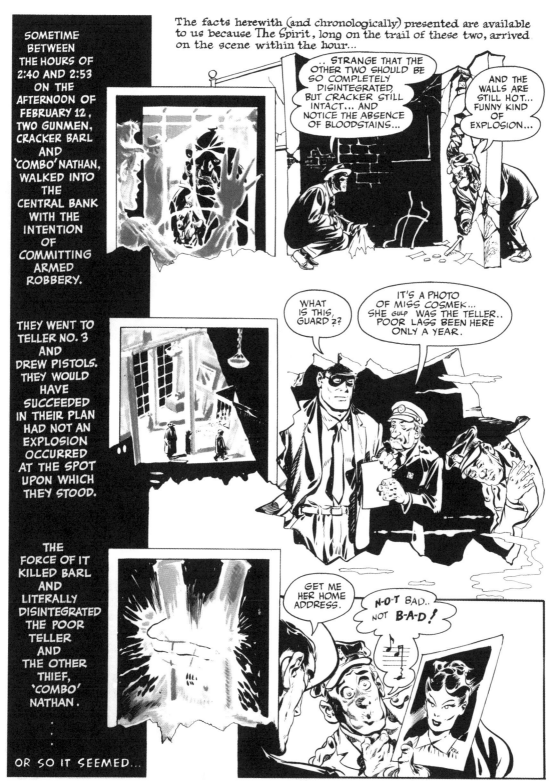

FIGURE 78: All the scenes here are shown from an eye-level perspective to reinforce realism.

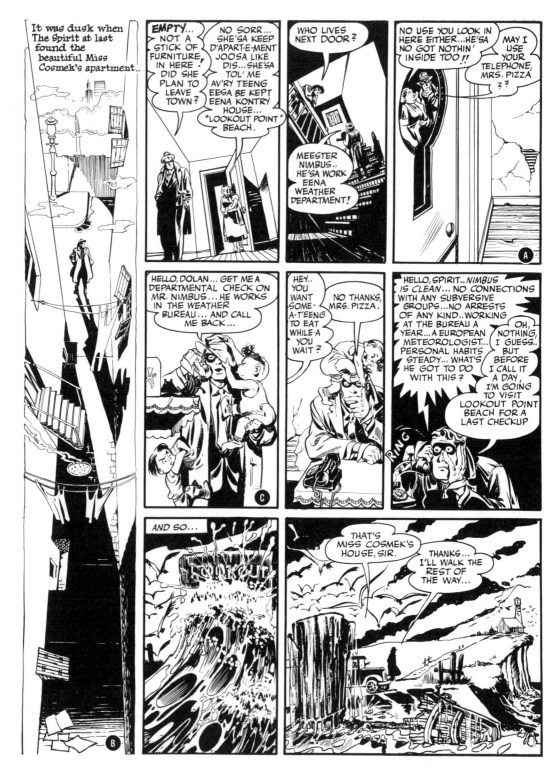

Comics and Sequential Art

FIGURE 79: **A** Do not confuse a close-up view with a change in perspective. The keyhole here is critical to the normalcy and narrative. **B** Here is the sole instance in which a bird's-eye view is undertaken. The intention is an orientation for a normal, everyday, believable setting. **C** Every effort is made to keep the plot believable. The babies crawling all over the hero, the steady flat "beat" of even ordinary (conventional) panels are all deliberately restrained.

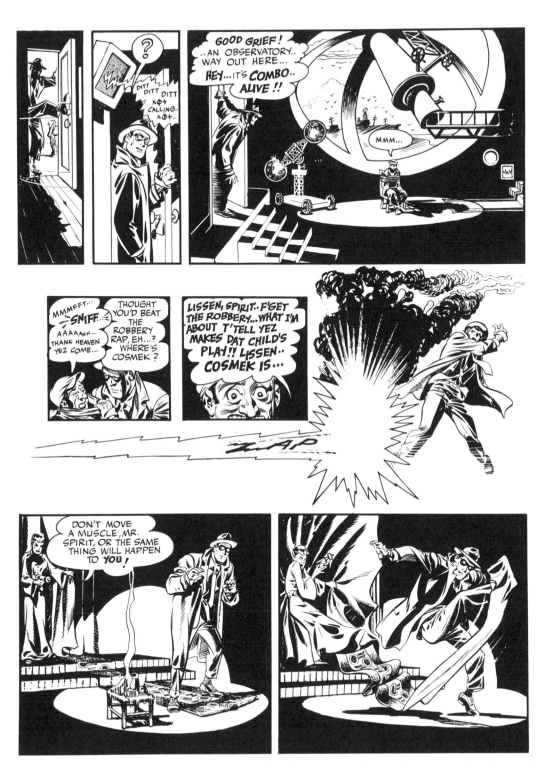

FIGURE 80: Even in the face of a provocative opportunity like this astronomy laboratory, the eye-level discipline is rigidly maintained.

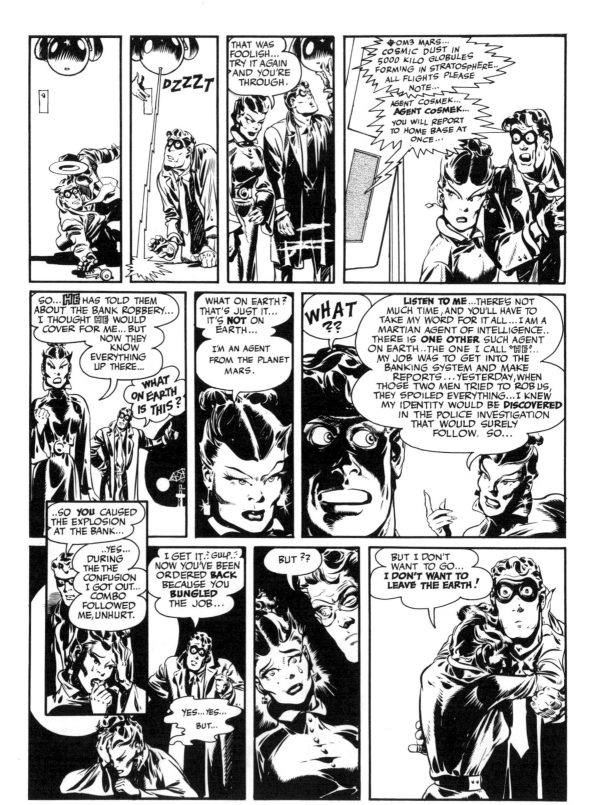

FIGURE 81: The profusion of close-ups here is a deliberate stratagem to lead the reader into an emotionally charged last panel.

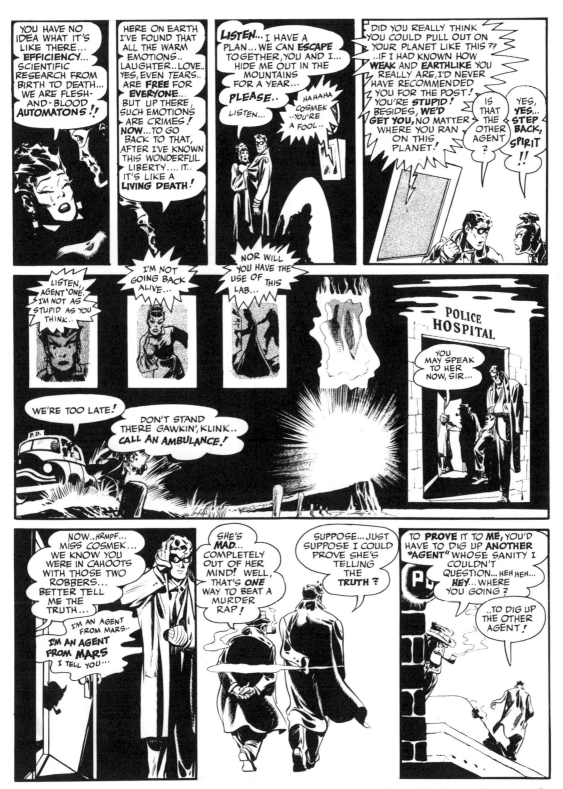

FIGURE 82: By now the reader's involvement is predicated on a sense of normalcy fostered by the unrelenting use of a flat-on perspective.

FIGURE 83: So, in the final resolution, where the sense of realism is so critical to the surprise ending, the perspective that was used throughout the story is rigidly maintained.

A simple example of overkill in layout and perspective is shown in FIGURES 84 and 85. Either of these are valid renderings of the action, if taken out of context. But, when examined in light of their service to the story they are not useful.

Read the story as it was originally presented and then compare the alternate treatment given for the last two tiers on the last page. Below, a varied perspective is used as an end in itself—more for the sake of "picture-interest" than storytelling. These two goals in comics are not always compatible, and one must weigh which is primary at any juncture: the visual impact or the narrative demands of the story.

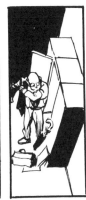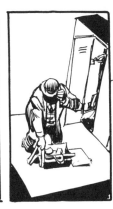

FIGURE 84: ALTERNATE ENDING A—The forced bird's-eye perspective removes the reader from direct intimate involvement. This distraction interrupts his sense of normalcy.

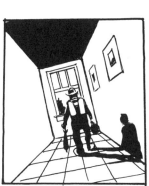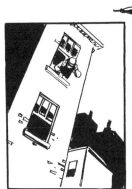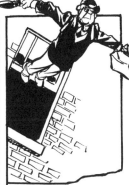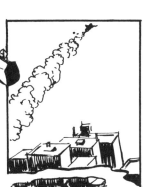

FIGURE 85: ALTERNATE ENDING B—Here the reader's position is made even more remote. Furthermore, removing the protagonist from close-up and suddenly allowing him to burst from the panel concentrates everything on the dramatic act of flying. Flying, in this tier, is not as important as surprising the reader.

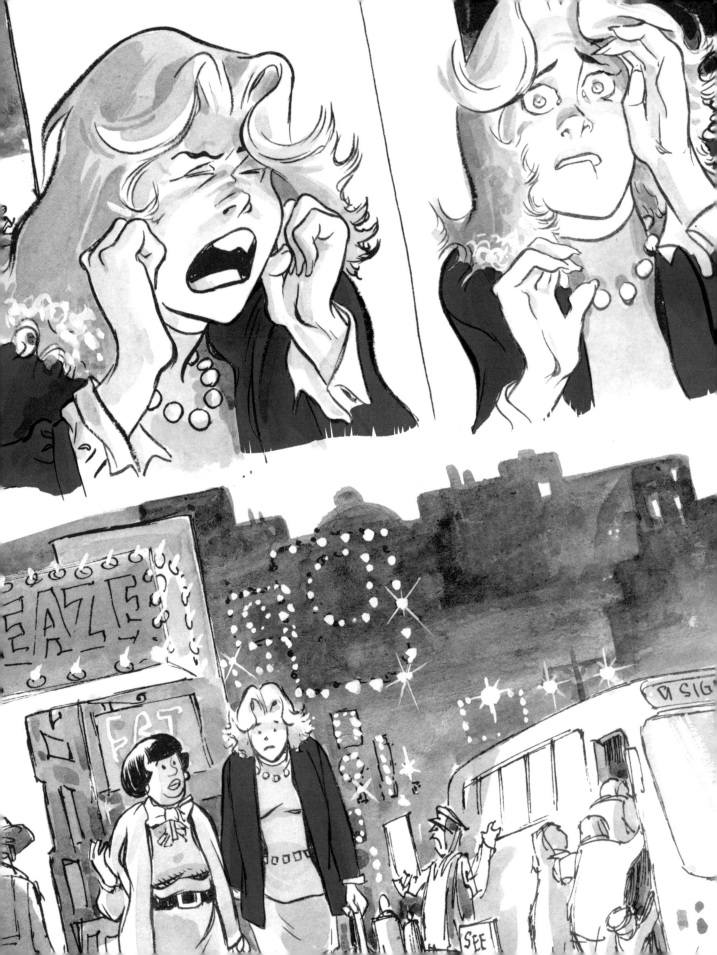

CHAPTER 5

EXPRESSIVE ANATOMY

By far the most universal image with which the sequential artist must deal is the human form. Of all the innumerable inventory of images that fill the human experience, the human form is the one most assiduously studied, and hence the most familiar.

The human body, the stylization of its shape, and the codifying of its emotionally produced gestures and expressive postures are accumulated and stored in the memory, forming a non-verbal vocabulary of gesture. Unlike the frame device in comics, the postures of humans are not part of comic strip technology. They are rather a record "of purposeful movement…a motor discharge… that can be a carrier of the expressive process."[1] They are part of the inventory of what the artist has retained from observation.

Not much is known about where or how the brain stores the countless bits of memory that contribute to or become comprehensible when arranged in a certain combination. But it is patently clear that when a skillfully limned image is presented it can trigger a recall that evokes recognition and the collateral effects on the emotion. We are obviously dealing here with the common memory of experience.

It is precisely because of this that the human form and the language of its bodily movements become one of the essential ingredients of comic strip art. The skill with which they are employed is also a measure of the author's ability to convey his idea.

The relentless growth of communications technology since the dawn of man's intellectual history has served to universalize images of common human experience. Their employment in repetitive glyphs (later distilled into letters for language) makes them a code allowing memorization and deciphering. Perhaps the most obvious demonstration of this is in Egyptian hieroglyphics.

There have been many attempts to codify human postures and the emotions they register or reflect. In a popular modern book this was referred to as "body language," and a wide range of body posturing was assembled and defined.

[1] Hans Prinzhorn, *Artistry of the Mentally Ill,* a contribution to the psychology and psychopathology of configuration (Springer-Verlag, 1972).

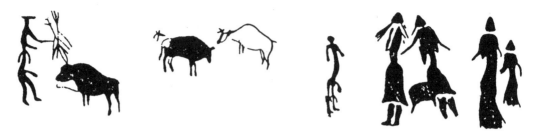

ABOVE: Early cave drawings are an example of written communication using familiar images.

ABOVE: Over time, Egyptian friezes became further stylized.

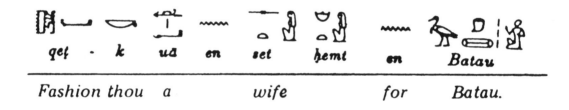

qef	-	k	ua	en	set	hemt	en	Batau
Fashion	thou		a		wife		for	Batau.

ABOVE: Finally, Egyptian hieroglyphics codified the stylized images into repeatable symbols to form a usable written language.

The fact is, however, that the "reading" of human posture or gesture is an acquired skill which most humans possess to a greater degree than they know. Because it has to do with survival instincts, humans begin to learn it from infancy. From postures we are warned of danger or told of love.

In comic book art, the artist must draw upon personal observations and an inventory of gestures, common and comprehensible to the reader. In effect, the artist must work from a "dictionary" of human gestures.

It is appropriate at this point, I believe, to defend the vanity of trying (like Leonardo da Vinci) to make a science of art. Formal or organized recorded human communication began as communication of visual information. It is therefore not surprising that the artist can count on wide reader reception when a common gesture is limned so that it is easily recognized. The skill (and science, if you will) lies in the selection of the posture or gesture. In print, unlike film or theater, the practitioner has to distill a hundred intermediate movements of which the gesture is comprised into one posture. This selected posture must convey nuances, support the dialogue, carry the thrust of the story and deliver the message.

ABOVE: A MICRO-DICTIONARY OF GESTURES—These very simple abstractions of gestures and postures deal with external evidence of internal feelings. They serve to demonstrate, also, the enormous bank of symbols we build up out of our experience. **A** Anger. **B** Fear. **C** Joy. **D** Surprise. **E** Deviousness. **F** Threat. **G** Power.

How exaggeratedly or subtly a posture is drawn is a matter of style: it is different for each artist, and both exaggeration and subtlety of posture go in and out of fashion over time.

THE BODY

In comics, body posture and gesture occupy a position of primacy over text. The manner in which these images are employed modifies and defines the intended meaning of the words. They can, by their relevance to the reader's own experience, invoke a nuance of emotion and give auditory inflection to the voice of the speaker (see FIGURE 86).

If the skill with which an actor emulates an emotion is, in large part, the criterion for evaluating his or her ability, certainly the artist's performance at delineating the same on paper must be measured with the same yardstick. In comics art this property is widely employed.

It would take a book in itself to catalog the thousands of gestures and postures with which humans communicate visually. For the purpose of this discussion, it is necessary only to examine and demonstrate the relationship of gesture or posture to dialogue and to observe the result of its application.

A GESTURE, generally idiomatic to a region or culture, tends to be subtle and limited to a narrow range of movement. Usually, it is the final position that is the key to its meaning. The selec-

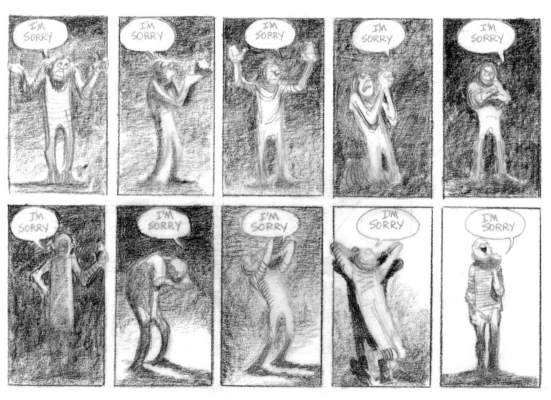

FIGURE 86

ABOVE: In this example there are a few instantly recognizable gestures. Of the thousands of possible gestures that accompany human postures or attitudes, a surprising number are universal.

tion process here is confined to the context within a sequence. It must clearly convey intended meaning. The reader must agree with the selection. The reader decides whether the choice is appropriate.

A POSTURE is a movement selected out of a sequence of related movements in a single action. In FIGURE 87, one posture must be selected out of a flow of movements in order to tell a segment of a story. It is then frozen into the panel in a block of time.

In a panel selected from a series, the frozen posture tells its story—giving information about the before and after of the event.

In FIGURE 88, a whole sequence of postures that immediately precede the one shown is assumed. It is acceptable simply because the moment of time

IT WOULD TAKE A BOOK IN ITSELF TO CATALOG THE THOUSANDS OF GESTURES AND POSTURES WITH WHICH HUMANS COMMUNICATE VISUALLY.

FIGURE 87: These examples summarize a series of very subtle movements which take place in a very *short* period of time—but which are meant to imply a "held" motion in the flow of narrative.

ABOVE: This event takes place over a *short* period of time—but because there was a need to clearly show the source of the weapon (rock) and the power needed to effectively use it, the action was broken up into three panels.

frozen in this action sums it up with the understanding that the viewer knows (and can supply imaginatively) that there could not have been any other set of postures possible in order to arrive at this point. The postures that follow immediately are also assumed and it is unnecessary to depict them unless the next panel depends on the outcome of the movement.

FIGURE 88: Out of a series of eight motions that comprise an action of about thirty seconds' duration, one representative post is "frozen." It is selected after considering its relationship to preceding and succeeding panels.

ALTERNATE SELECTION OF POSTURE

If, for example, the narrative requires that the final thrust of the warrior's shield is the main point in this segment of narrative, then the posture selected is the final movement in this thirty-second motion (see FIGURE 89).

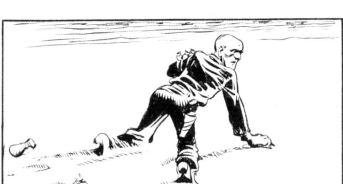

NOTHIN'...JUST A MIRAGE...

INTERMEDIATE ACTION

ABOVE: This three-frame sequence is taken out of a series of movements that takes place over a period of perhaps one hour or more. The selection, or "freezing," of key postures seeks to communicate time as well as emotion. Each pos-ture is of equal importance in the narrative. The in-between actions are implied by each pose shown. Out of these, the reader can deduce the choreography.

FIGURE 90 demonstrates a more complex appli-cation and deployment of postures and gestures selected out of intermediate actions. Here is an effort to give the reader much more of an insight into a character's lifestyle—to make a sociologi-cal observation.

FIGURE 90: From Will Eisner's "New York: The Big City," first published in *The Spirit Magazine* #35, June 1982.

THE FACE

In most conventional books on human anatomy it is customary to treat the head as an appendage. In comic book art this part of the anatomy invites the most attention and involvement. For the sake of this discussion, the face is studied without regard to individual personality.

FIGURE 91 demonstrates the response of muscular reflex (contortion) in the face that reflects or gives evidence of an inner emotion.

The distinction between posture and gesture in the face is less definable because of the limits of its anatomy. Except for the ears and nose, the surface of the face is in constant motion. Eyebrows, lips, jaws, eyelids and cheeks are responding to muscular movements triggered by an emotional switchboard in the brain.

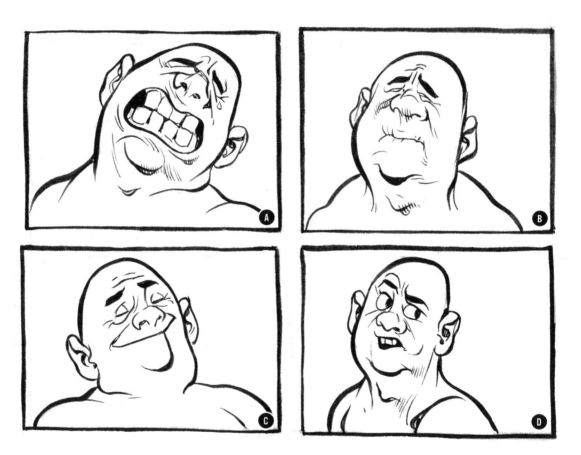

FIGURE 91: **A** Pain...a painful effort...a pain in some part of the body. **B** Discomfort in some part of the body...perhaps internal. **C** Comfort that extends over the entire body. Pleasure. **D** Body is poised for some movement, flight or action.

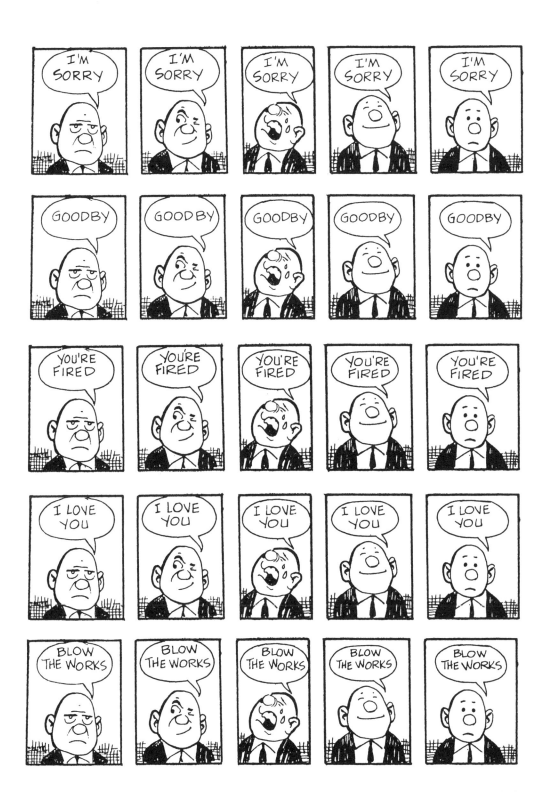

ABOVE: Here is a demonstration of the effect of a commonly understood set of facial postures or grimaces, which give meaning to a parallel set of statements. The intention is to display the application of facial expressions as a vocabulary.

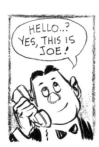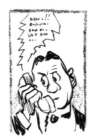

ABOVE: This sequence simply illustrates the adverbial effect of the posture of the head on the movement of features on the surface of the face. Together they communicate the emotional reaction to an unheard (by the reader) telephone message.

The surface of the face is, as someone once put it, "a window to the mind." It is familiar terrain to most humans. Its role in communication is to register emotion. On this surface the combinations of the movable elements are expected by the reader to reveal an emotion and act as an adverb to the posture or gesture of the body. Because of this relationship, the head (or face) is often used by artists to convey the entire message of bodily movement. It is the one part of the body with which the reader is most familiar. The face also, of course, provides meaning to the spoken word. In contrast to the body, its gestures are more subtle but more readily understood. It is also the part of the body that is most individual. From the reading of a face, people make daily judgments, entrust their money, political future and their emotional relationships. I have often mused that if animals' faces were more flexible, more individual, more reflective of emotions, they might be less likely to be killed by humans.

THE BODY AND THE FACE

The employment of body posture and facial expression (both having equal attention) is a major undertaking and an area of frequent failure. Properly and skillfully done, it can carry the narrative without resorting to unnecessary props or scenery. The use of expressive anatomy in the absence of words is less demanding because the latitude for the art is wider. Where the words have a depth of meaning and nuance, the task is more difficult.

The following example, "Hamlet on a Rooftop" (1981), attempts to address such a challenge (see FIGURES 92 through 101).

FIGURE 92: (OPPOSITE) This represents an example of a classic situation—that of author vs. artist. The artist must decide at the outset what his "input" shall be; to slavishly make visual that which is in the author's mind or to embark on a raft of the author's words onto a visual sea of his own charting.

HAMLET ON A ROOFTOP

His father is dead, mysteriously! His mother, within but a month, marries his uncle! So soon?, so soon? Can there be anything other than **SOMETHING ROTTEN** here? Can it be anything but murder!? Well, then, if murder it be all he values, indeed, his manhood cries out for retribution vengeance ... to honor the filial duty his father's voice demands in the hot cauldron of his mind! Aye, to punish them, to **MURDER HIS MOTHER AND UNCLE**... as they lay in violation of his code!!! ...or perhaps something more unspeakable within him.

Yet... can he find in himself the capacity to commit so unnatural an act and in doing it forfeit the love of Ophelia, his betrothed? Wait... hold still for a moment, cling briefly to a passing raft of reason before it leaves the brain, before surrendering to the swift river of his passion, and so to be carried out into the turgid sea of violence from which there is no return.

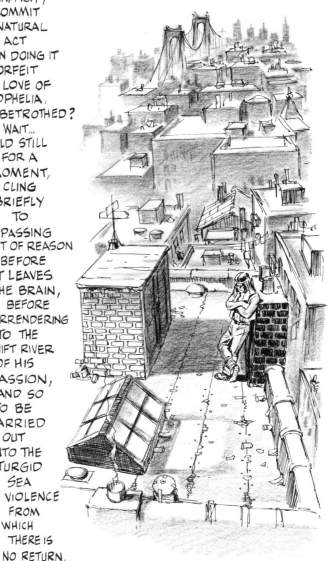

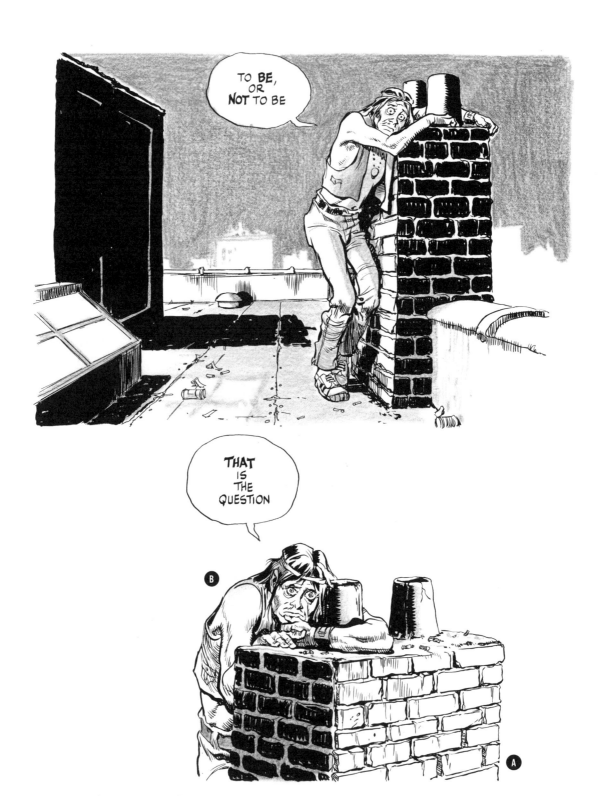

FIGURE 93: In this experiment, William Shakespeare's words are intact. The famous soliloquy is broken up into balloons at the artist's discretion. The intent here is to permit a meaningful fusing of word, imagery and timing. The result should provide the reader with necessary pauses. The art- ist here functions as an actor and, in the process, gives his own meaning to the lines. **Ⓐ** Furniture employed in intimate involvement with the actor gives the "background" story value because it is part of the action. **Ⓑ** The character's gesture signifies contemplation.

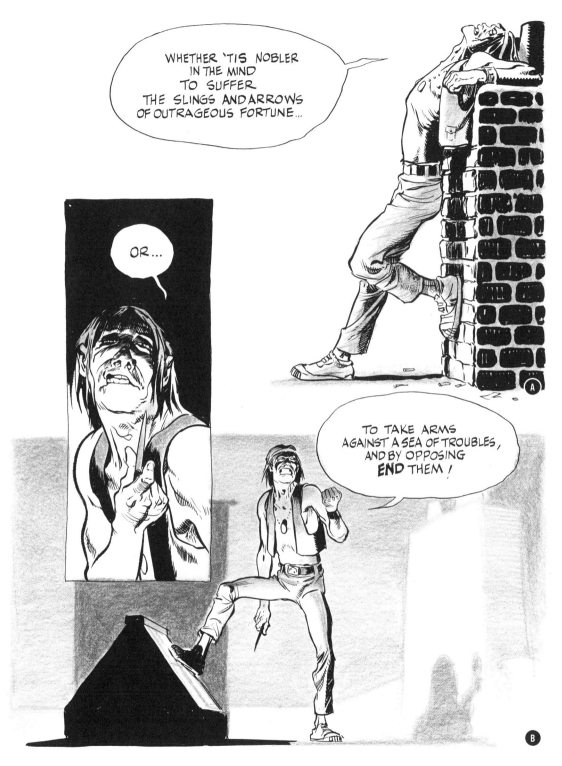

FIGURE 94: Here, the postures are more than a classical portrayal of emotions. This man is not the Danish Prince Hamlet! His gestures and postures are derivative of his special background. The question of how he would deliver the standard gesture for self-doubt and internal agony is the artist's real challenge! **A** Submission to a "heavy" thought. **B** Bravado: he envisions himself as challenging the forces of his troubles.

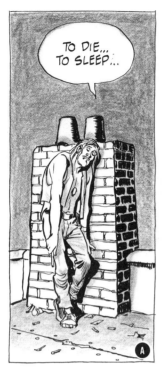

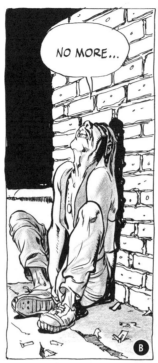

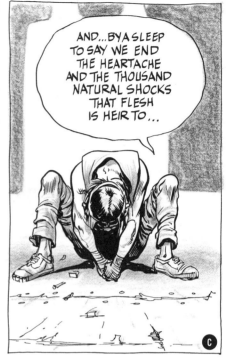

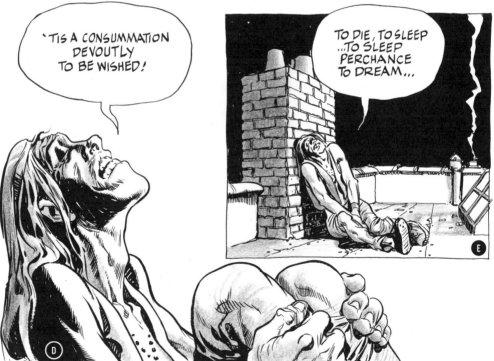

FIGURE 95: The language of posture is universal and interchangeable—the application is not. **A** Exhaustion: beaten by the enormity of his problems. **B** Seeking comfort, he lets his body slide down along the wall. **C** He retreats into his refuge: sleep. **D** Wishing with all his might. **E** Withdrawing into sleep or oblivion, he assumes an almost fetal posture.

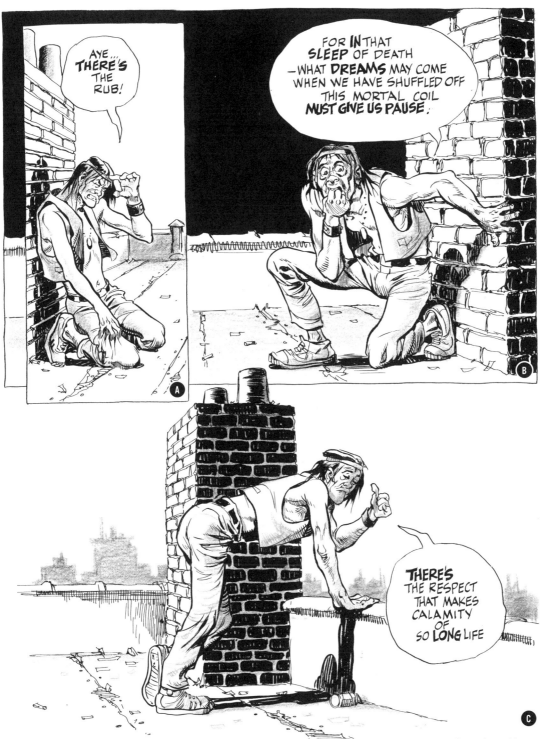

FIGURE 96: Ⓐ Awake again to the thoughts that will not leave him! Ⓑ Terror: he realizes his options. Ⓒ Candor: addressing the unseen manipulator of his fate.

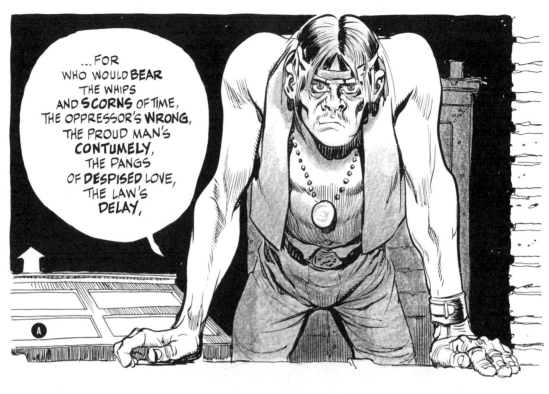

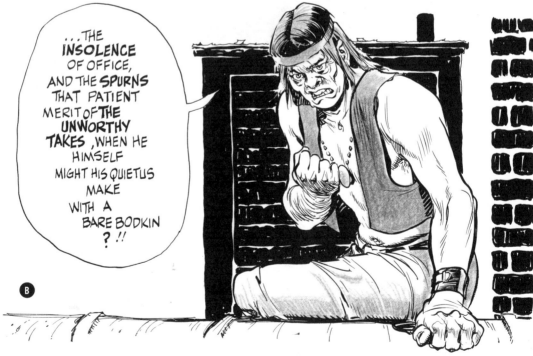

FIGURE 97: Ⓐ Anger: now he builds his resolution. Ⓑ Arguing: he begins to make a case to buttress his growing resolve.

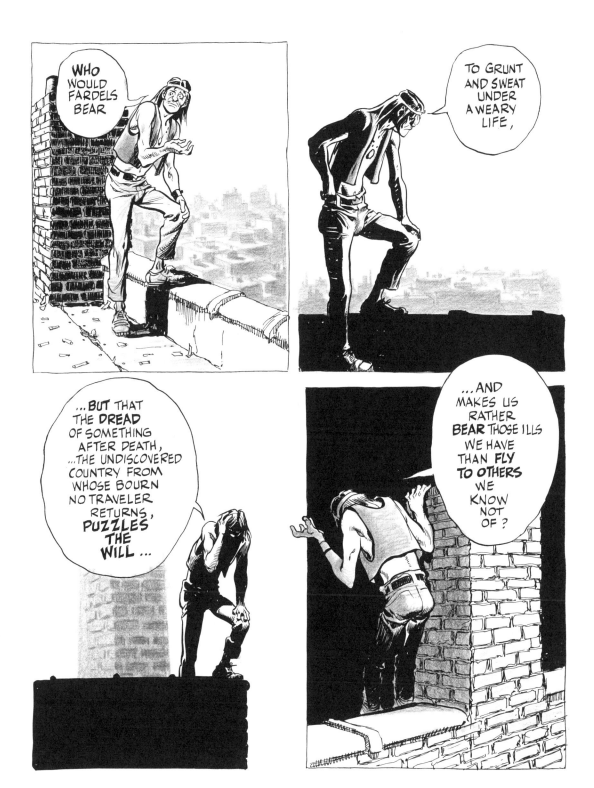

FIGURE 98: Debating: the postures of a courtroom advocate.

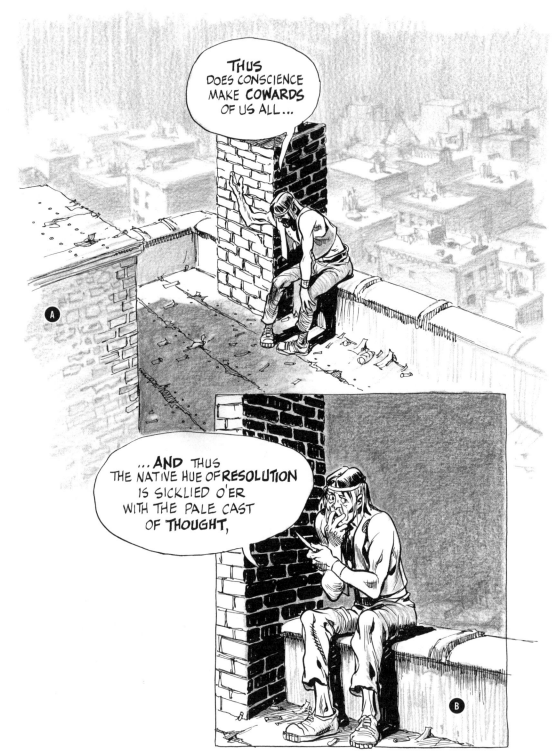

FIGURE 99: **A** The use of a long shot here is meant to reinforce realism—and to try, in that way, to deal with the problem of putting Shakespeare's language in the mouth of such an unlikely spokesman. **B** Hesitation: a recurrence of doubt.

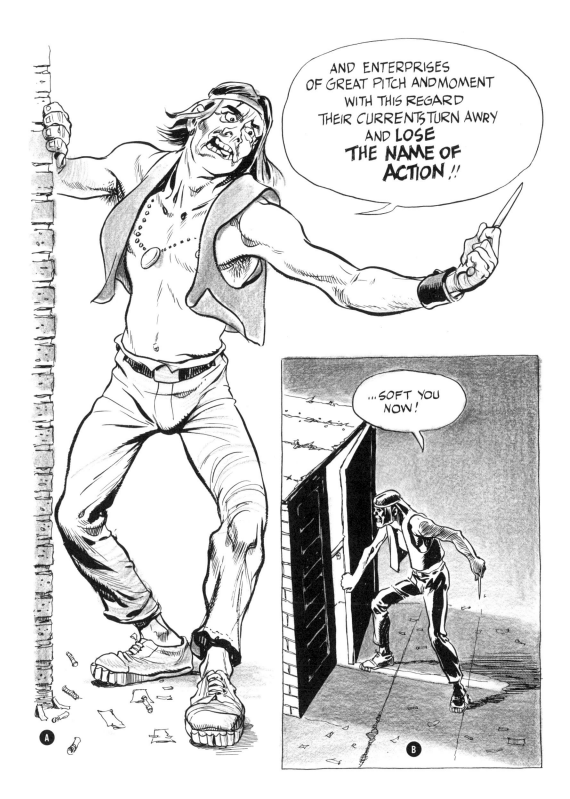

FIGURE 100: **Ⓐ** Resolve! **Ⓑ** Attack: he now moves to act upon his resolve.

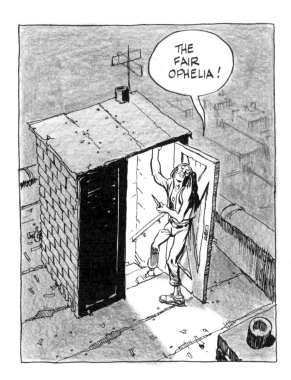
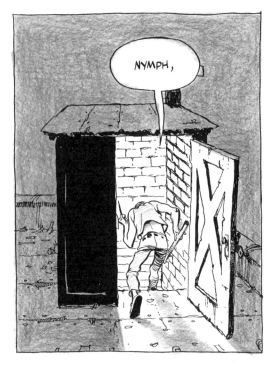
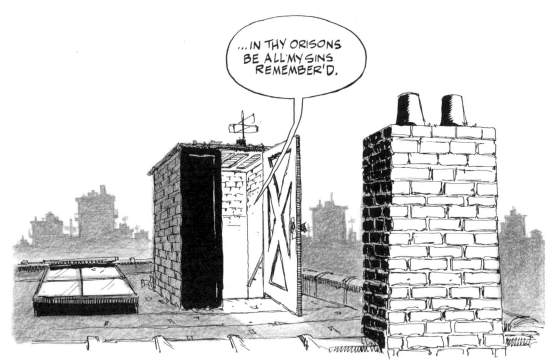

FIGURE 101: This wedding of Shakespearean language with a modern denizen of the ghetto may not be appropriate, but the exercise serves to demonstrate the potential of the medium because the emotional content is so universal.

EDITOR'S NOTE A book-length expansion of the themes in this chapter can be found in *Expressive Anatomy for Comics and Narrative,* the final volume of Will Eisner's educational trilogy.

CHAPTER 6

WRITING AND SEQUENTIAL ART

"Writing" for comics can be defined as the conception of an idea, the arrangement of image elements and the construction of the sequence of the narration and the composing of dialogue. It is at once a part and the whole of the medium. It is a special skill, its requirements not always in common with other forms of writing, for it deals with a singular technology. It is closest in requirements to playwriting, but for the fact that the writer, in the case of comics, is often also the image-maker (artist).

In sequential art the two functions are irrevocably interwoven. Sequential art is the act of weaving a fabric.

In writing with words alone, the author directs the reader's imagination. In comics the imagining is done for the reader. An image once drawn becomes a precise statement that brooks little or no further interpretation. When the two are mixed, the words become welded to the image and no longer serve to describe but rather to provide sound, dialogue and connective passages.

THE WRITER AND THE ARTIST

In order to consider, separately, the role of the writer, it is necessary to arbitrarily limit the "writing" for comics to the function of conceiving the idea and the story, creating the order of telling and fabricating the dialogue or narrative elements. With this as a given, we can arrange an order of progression which assembles itself as follows.

The idea and the story or plot in the form of a written script includes narrative and dialogue (balloons). The deployment of words, and the architecture of the structure composed, expands or develops the concept of the story. Directions to the artist (description of panel and page content) carry that idea from the mind of the writer to the illustrator.

Each component pledges allegiance to the whole. The writer must at the outset be concerned with the interpretation of his story by the artist, and the artist must allow himself to be a captive of the story or idea. The separate considerations of the writing and drawing functions are directly involved with the aesthetics of the

medium because the actual segregation of the writing and art function has proliferated in the practice of modern comics.

Unlike theater (including cinema), in which the technology of its creation demands by its very nature the coordinated contributions of many specialists, comics have a history of being the product of a single individual.

The departure from the work of a single individual to that of a team is generally due to the

WHO IS THE "CREATOR" OF A COMIC PAGE WHICH WAS WRITTEN BY ONE PERSON, PENCILED BY ANOTHER AND INKED, LETTERED (AND PERHAPS COLORED OR HAD BACKGROUNDS CREATED) BY STILL OTHERS?

exigency of time. More often the publisher ordains it out of a need to meet publication schedules, control his property when he owns a proprietary character, or when his editor assembles a team to suit an editorial thrust.

Many times the artist will bow to the editor's opinion that he has limited writing skills—or the artist will voluntarily abdicate the writing role. So, to accommodate the dictates of the publisher or schedule, or merely because it is assumed that this is the way comics are made, the artist will engage the services of a writer, or the writer will engage the skills of an artist.

After a half century of this sort of separation, it is not unusual to find (particularly in large com-

ics publishers) well-regarded and well-established comics creators who have specialized in either writing or art for their whole careers, without ever seriously making an attempt at the other.

A bemusing result of this separation of art and writing has been the dilemma faced by modern comic book publishers when they have sought to return to the creator the "originals" after publication. Who is the "creator" of a comic page which was written by one person, penciled by another and inked, lettered (and perhaps colored or had backgrounds created) by still others? This question becomes increasingly moot as more creators produce comics employing digital means, and the "originals" exist on a computer in an infinitely copyable format.

A factor that has always had an impact on comics as an art form is the underlying reality that we are dealing with a medium of expression that is primarily visual. Artwork dominates the reader's initial attention. This then lures the artist to concentrate his skills on style, technique and graphic devices that are designed to dazzle the eye. The reader's receptivity to the sensory effect and often his evaluation of its worth reinforces this concern and encourages the proliferation of artistic athletes who produce pages of absolutely stunning art held together by almost no story at all.

THE APPLICATION OF "WRITING"

In comics that serve an essentially visually oriented audience or where the story demands are oriented toward a simple superhero, the action and style of art becomes so dominant that it mitigates the weave of writing and art. Another factor in the loosening of this fabric is the proce-

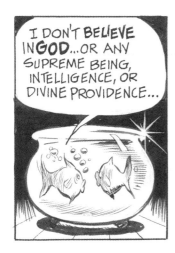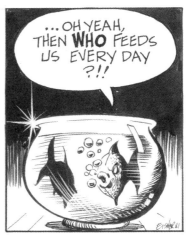

FIGURE 102

dure whereby the writer gives the artist the bare summary of a plot. The artist proceeds to create an entire sequence of art, composing his panels around a general assumption of unwritten dialogue and the satisfaction of his perception of the plot's requirements. The completed work (at this point little more than a tapestry) is returned to the writer, who must then apply dialogue and connecting narrative. Under these circumstances there could occur a struggle for identity as the writer, seeking to maintain his equity in the end product, overwrites in spaces arbitrarily allocated to him by the artist, who has created an interpretation that is now irrevocable.

WORDS AND ART: INSEPARABLE

FIGURE 102, a simple example of the interdependency of words (text) and image (art), undertakes a theme of some sophistication. In this case the art without the text would be quite meaningless. Here the artist is also "writing."

The positioning of the fish and the unembellished rendering of the art does not intrude on the theme. The deliberate pause (timing) by the insertion of a wordless panel adds weight and power to the punch line. Making the words BELIEVE, GOD and WHO boldface adds sound and disciplines the reader's internal ear. In reality, the reader is being asked to supply (or "hear") the sound internally. This is an aspect of writing especially adaptable to comics. The "control" of the *reader's ear* is vital if the meaning and intent of the dialogue is to remain as the writer intended it.

THE APPLICATION OF WORDS

Assume for the following example a script (segment) that is prepared by either the writer or the artist, which deals with a fugitive who is running away from pursuing police (see FIGURES 103 and 104). Here we seek a demonstration of the various possible applications of text, which include dialogue, connecting narrative and description. Remember that in creativity there is no "right" or "wrong."

In view of this interdependence there is therefore no choice (in fairness to the art form itself)

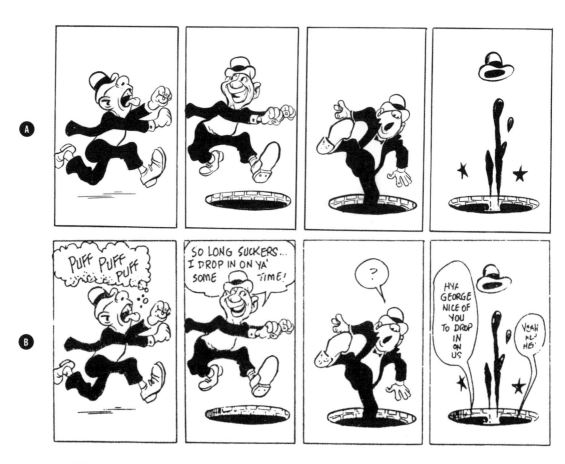

FIGURE 103: **Ⓐ** (Humor) A pure visual! The "writing," which may either have preceded the creation of the art in the form of a couple of sentences of description or been described orally, is dispensed with entirely. **Ⓑ** (Humor)Since humor deals in exaggerated simplification, so must the "writing." Because of the simplicity of the art, text can (and has the freedom to) alter either meaning or intent. It can also affect the humor by adding a dimension of incongruity.

FIGURE 104: (OPPOSITE) **Ⓒ** (Realism) A minimum of word usage. Words here are employed for sounds. The artist shoulders the burden of conveying the action and the emotion of the fugitive by imagery alone. **Ⓓ** (Realism) Balloons are more liberally used to reinforce the theme. **Ⓔ** (Realism) A heavy application of narrative seeks to add dimension to the art and tries to participate in the storytelling by repeating (or reinforcing) what the images are trying to tell.

C

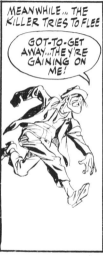
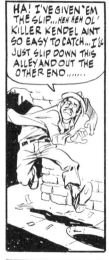
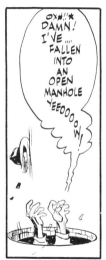
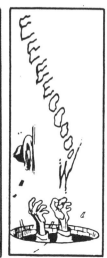

C

D

MEANWHILE... THE KILLER TRIES TO FLEE

GOT-TO-GET AWAY...THEY'RE GAINING ON ME!

HA! I'VE GIVEN 'EM THE SLIP...HEH HEH OL' KILLER KENDEL AINT SO EASY TO CATCH...I'LL JUST SLIP DOWN THIS ALLEY AND OUT THE OTHER END......

...BEHIND THE BACK OF THE BUILDING... WOT... ...TH'

OX#!!★ DAMN! I'VE.... FALLEN INTO AN OPEN MANHOLE YEEOOOOW!

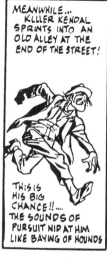
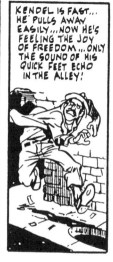
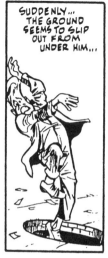
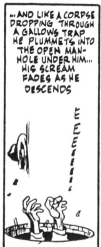

E

MEANWHILE... KILLER KENDAL SPRINTS INTO AN OLD ALLEY AT THE END OF THE STREET!

THIS IS HIS BIG CHANCE!!.... THE SOUNDS OF PURSUIT NIP AT HIM LIKE BAYING OF HOUNDS

KENDEL IS FAST... HE PULLS AWAY EASILY...NOW HE'S FEELING THE JOY OF FREEDOM...ONLY THE SOUND OF HIS QUICK FEET ECHO IN THE ALLEY!

SUDDENLY... THE GROUND SEEMS TO SLIP OUT FROM UNDER HIM...

...AND LIKE A CORPSE DROPPING THROUGH A GALLOWS TRAP HE PLUMMETS INTO THE OPEN MAN-HOLE UNDER HIM... HIS SCREAM FADES AS HE DESCENDS

Writing and Sequential Art

but to recognize the primacy of the writing. In doing so, however, one must then immediately acknowledge that in a perfect (or pure) configuration the writer and the artist should be embodied in the same person. The writing (or the writer) must be in control to the very end.

STORY AND IMAGERY

In practice the creator, given or having conceived the idea, sets about to develop it with words and imagery into a unified whole. It is here that the graphic elements ascend to dominance. For the end product is, after all, to be read as a total visual. It is this "mix" that is, in the final analysis, the ultimate test of the success and quality of the sequential art effort.

STORY DEVELOPMENT

From the outset the conception and writing of a story is affected by the limitations of the medium. These virtually dictate the scope of a story and the depth of its telling. It is for this reason that stories and plots of simple, obvious action have long dominated comic book literature. The selection of a story and the telling of it become subject to limitations of space, skill of the artist and the technology of reproduction. Actually, from the viewpoint of art or literature, this medium can deal with subject matter and theme of great sophistication.

Of the many elements of a story the most amenable to imagery are scenery and action. It is also reasonable to expect this medium to deal with abstractions that can be conveyed by human action and scenery. The dialogue, which gives voice to the thought processes, has the effect of rendering action meaningful. Text used in the introduction of a sequence or interposed between panels is employed to deal with the passage of time and changes in locale. In this connection, perhaps the most useful (and most used) word in comics is "MEANWHILE."

There is no absolute ratio of words-to-picture in a medium where words (lettering) are in themselves part of the form. Sequential art operates under a rule of thumb that defines an image as either a "visual" or an "illustration." I define a visual as a series or sequence of images that replace a descriptive passage told only in words. An illustration reinforces (or decorates) a descriptive passage. It simply *repeats* the text.

It is the "VISUAL" that functions as the purest form of sequential art, because it seeks to employ a mix of letters and images as a language in dealing with narration.

At the outset the creator makes a determination as to the nature of the story. He must determine if he is dealing with the exposition of an idea, a problem and its solution or the conveyance of the reader through an experience.

The style of treatment (i.e., humorous or realistic) has an obvious importance in the considerations that follow. Most often this is a predetermined concept and is eliminated from conscious choice or protracted deliberation. It is nonetheless important to factor it in the following steps.

In the next step the story is "broken down." At this time the application of the story and plot to the limitations of space or technology of the conveyance takes place. In printed comics, page size, number of pages, reproduction process and available colors influence the "breakdown." In digital comics, a comics creator might take into account

whether the story will be broken up into pages at all, and if it is, whether the comic will maintain a standard format or change from page to page. Sometimes, particularly in the situation where a script is provided to the artist by a writer, the fundamental breakdown is performed by the writer in the process of his work. The writer initiates the breakdown and expects (very often with a fervent prayer) the artist to reproduce or convert into visuals the description of action and compositional instructions that accompany the dialogue. Obviously, a close rapport between the two will prevent impossible demands by the writer and confounding modifications (generally in the form of abbreviations and downright omissions) by the artist who is often struggling more with the limitations of space, time and skill of rendering (not to mention laziness) than with intellectual considerations.

It takes a very sophisticated writer of long experience and dedication to accept the total castration of his words, as, for example, a series of exquisitely written balloons that are discarded in favor of an equally exquisite pantomime. Where the artist must deal with or is forced to preserve the inviolability of the writer's words (as in dialogue or narrative passages), the result is often a string of "talking heads." Where the writer is capable of accompanying his text with sketches as an integral part of the script, the problem is less severe. Of course, where the writer and the artist are the same person, these problems are some-

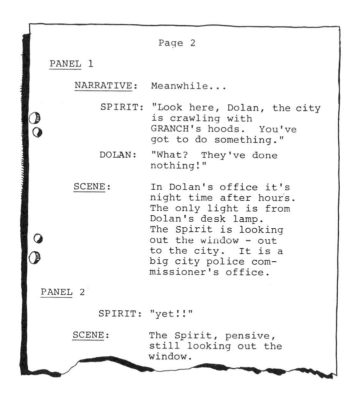

ABOVE AND OVERLEAF: This is a simplified example of an average script. In practice the presentation style of the script varies with the standards of the publishing house—or the agreement between artist and writer. This script deals with only one page of a story.

133

Writing and Sequential Art

PANEL 3

DOLAN: "Unless..someone...
 on the side of the
 law,of course...were
 to...!"

SCENE: Dolan's getting a
 brainstorm. His face
 shows a crafty idea
 is aborning. Per-
 haps a close up, his
 face lit by the lone
 lamp.

PANEL 4

NARRATIVE: Two hours later....

SCENE: The waterfront of
 Central City. Fog
 swirls about the
 piles and rotting
 planking of the
 wharf. We see the
 Spirit standing in
 the one spot of
 light provided by
 a lone lamp post.
 The hull of a docked
 tanker is barely
 visible in the mist.
 In a corner of the
 panel we see a
 shadowy figure — —
 obviously a thug.

PANEL 5

THUG: "Welcome to our
 turf...don't move
 a muscle!!"

SPIRIT: "Well, well...
 GRANCH's hos-
 pitality corps
 ...tch, tch!!"

SCENE: Close in on the Spirit
 ...Out of the shadows
 the thug moves close
 to the Spirit..We see
 his glistening knife
 blade pointed to just
 behind the Spirit's
 ear. The thug is
 dimly seen. The
 Spirit's posture is
 one of seeming sur-
 render.

what buried in the thinking process of the writer/artist and are laundered in the flow of decision-making. But he must, nevertheless, go through the entire process whether or not he does it on a set of thumbnails (writing dialogue as he goes) or follows the formality of typing a script for his own use. Here, at least, the writer's sovereignty and equity are no longer involved.

I have always been strongly of the opinion that the writer and artist should be one person. Failing that, and in the absence of any prior agreement between artist and writer, then I come down in favor of the dominance of the artist. This is not to free him from the obligation to work in service of the story originated by the writer. Rather, I expect him to shoulder this burden with the understanding that with the so-called freedom will come a greater challenge—that of employing or devising a wider range of visual devices and composition innovation. He should contribute to the "writing."

In any event, in any ideal scriptwriter-artist relationship the artist must assume the burden of two major freedoms: omission and addition. For those who would like to have a rule, these two might be useful.

LEFT: This flow chart shows the thinking process and the steps of development from a script of a single page (shown in detail on the preceding pages) to the penciled art ready to be inked or scanned for digital manipulation.

"IT IS THE 'VISUAL' THAT FUNCTIONS AS THE PUREST FORM OF SEQUENTIAL ART."

FOR JASON LUTES, THE CREATOR OF THE CRITICALLY acclaimed graphic novels *Jar of Fools* and *Berlin: City of Stones*, "cartooning is picture-writing." Each page and spread of Jason's books is carefully designed to propel the reader through the narrative. Careful consideration is given to how each panel functions individually and in relationship to the entire page. As a result, Jason's ambitious narratives never unintentionally confuse or disorient the reader.

When Jason was asked to "write" a graphic novel about Harry Houdini, it made sense that he would prepare thumbnail sketches for every page. These sketches were invaluable to the artist Nick Bertozzi: "When I teach, I show his thumbnails to my students as the Gold Standard for clear cartooning and visual storytelling."

① I see 'im! I see 'im!

② Hurray for Houdini!

③ Houdini!

④ THIS WAY TO THE
GREAT HOUDINI 🖓

GROUP MOVES INTO CROWD
AND DOWN STREET.

SIGNBOARDS

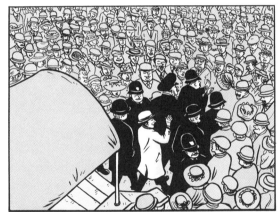

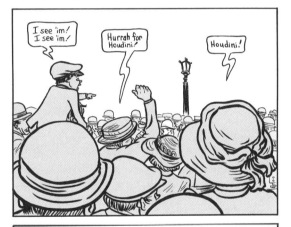

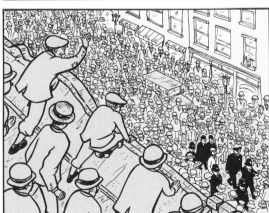

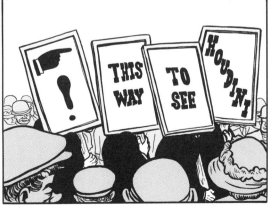

137

OMISSION OF TEXT

The artist should be free to omit dialogue or narrative that can clearly be demonstrated visually.

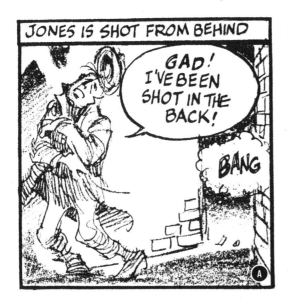

```
                              PANEL 1
         NARRATIVE:           Jones is shot from behind

           JONES:            "Gad, I've been shot in the
                              back."

          SCENE:             Show Jones being shot
                             in the back.
```

ABOVE: **A** As directed by script. **B** As artist modifies it.

ADDITION OF TEXT/ART

The artist should be free to enlarge a sequence of panels to create "timing" which reinforces the intent of the script.

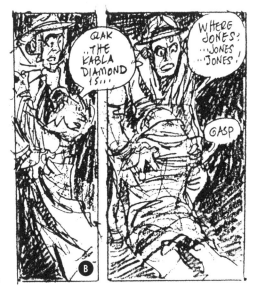

```
                        PANEL 1

        NARRATIVE:    Jones is shot from behind

           JONES:     "Gad...I've been shot from
                       behind."

           SCENE:     Show Jones being shot in
                       the back.

                        PANEL 2

        NARRATIVE:    Jones falls into the
                      Spirit's arms just as
                      he arrives.

           JONES:     "..Glak..The..Kabla
                      diamond is..gasp."

          SPIRIT:     "..Where?..Jones?..
                      Jones?"                    Ⓐ
```

ABOVE: Ⓐ The script as the writer produced it. Actually, the writer will generally concentrate on plot and dialogue leaving (or hoping for) skillful stagecraft to be supplied by the artist. Shown here is a two-panel segment of script. **Ⓑ** The artist has *added* two panels to create "timing" that increases the drama. By splitting the dying man's dialogue, the man's demise is visualized. Furthermore, the elimination of narrative makes the reading flow uninterrupted. This is storytelling by the artist.

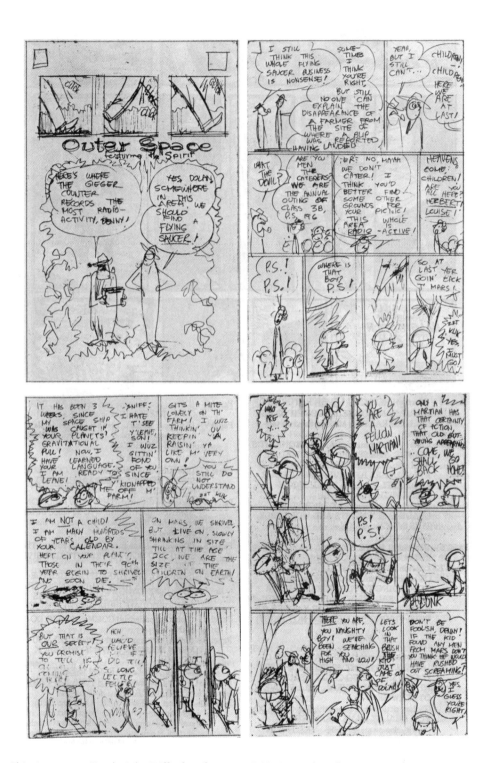

ABOVE: This story was written by Jules Feiffer for a four-page *Spirit* story to have been run October 12, 1952. It was never executed or published. This is an example of a script produced by a writer who is also skilled at drawing. Since he can sketch, he is able to supply the artist with visual stage directions. But an even more important ingredient is the writer's understanding of the artist's style and capabilities. The compatibility of the writer and artist is very evident here.

Page 1 [missing]

Page 2

Panel 1 -- (Martian) zzzt.. clk.. RUINED!

Panel 2 -- (Martian) MY BEAUTIFUL SPACESHIP DESTROYED BY THAT LITTLE BEAST WITH A PEPPERMINT STICK! HOW CAN I EVER REPAIR IT WITHOUT NEW PARTS?

Panel 3 -- (Martian) HOW CAN I EVER RETURN TO MARS? I AM DOOMED, DOOMED TO REMAIN ON EARTH! [Martian turns on television]

Panel 4 -- (Television Announcer) AND IN TONIGHT'S DEBATE, THE SPIRIT ANNOUNCED HE WILL PROVE THE POSSIBILITY OF FLY-ING SAUCERS BY REVEALING A FOUR FOOT REPLICA OF A SAUCER COMPLETE WITH ALL PARTS!

Panel 5 -- (Television Announcer) DESIGNED BY LEADING SCIENTISTS AND WORKABLE, THIS SAUCE... CLICK---
(Martian) HA!

Panel 6 -- (Martian) I HAVE FOUND A WAY TO RETURN TO MARS!

Panel 7 -- Caption: THAT NIGHT...
(Skeptical Scientist, in a television studio) ACCORDING TO PUBLIC RELEASES, A FLYING SAUCER WILL BE REVEALED HERE TONIGHT! I CAN ONLY SCOFF AT THIS! FLYING SAUCERS DO NOT EXIST!

Page 3

Panel 1 -- (Skeptical Scientist) THEY ARE MERE ILLUSIONS OF LIGHT. NOTHING THE SPIRIT CAN SAY, NO SO-CALLED SAUCER WHICH HE CAN REVEAL, WILL PROVE OTHERWISE!
(Dolan, sitting on a stage with The Spirit) DO YOU REALLY HAVE A SAUCER?
(Spirit, also on stage) SHH... YES. IT'S IN THE BACK ROOM!

Panel 2 -- Caption: IN THE BACK ROOM... [Martian sneaking into back room through open door]

Panel 3 -- [Silent -- probably long view showing past Martian to group of kids outside back room door. P.S. Smith (whose actual name is Algernon Tidewater) can be seen with kids and parents or teacher. Dolan is approaching room too, from opposite direction.]

Panel 4 -- (Parent or Teacher) P.S., WHERE ARE YOU GOING? [P.S. is leaving group, heading for back room.]

Panel 5 -- (Parent or Teacher, off panel) P.S., COME ON BACK!
(Martian) P.S.— THAT'S THE MONSTER WHO RUINED MY SHIP!

Panel 6 -- [Silent — P.S. enters back room and confronts Martian]

Panel 7 -- [Silent — P.S. probably knocks Martian out with his peppermint stick.]

Panel 8 -- (Dolan, just entering back room) P.S., DON'T GO IN THERE! [P.S. is entering saucer.]

Panel 9 -- [Saucer is taking off with P.S. in it] (Dolan, having entered now-empty back room) NOW, WHERE DID HE GO!

Page 4

Panel 1 -- (Skeptical Scientist in studio) IN CONCLUSION, I REPEAT, THESE SAUCERS DO NOT EXIST!

Panel 2 -- (Skeptical Scientist) THEY ARE ILLUSIONS! ...MERE... ILLUSIONS! [As he talks, we see behind him through window a view of the saucer flying by.]

Panel 3 -- (Television Announcer, gesturing toward The Spirit) AND NOW FOR REBUTTAL, I GIVE YOU THE SPIRIT!

Panel 4 -- (Spirit) MY ONLY REBUTTAL, GENTLEMEN, WILL BE AN ACTUAL DEMONSTRATION OF A FLYING SAUCER! COMMISSIONER DOLAN, BRING IN THE SAUCER!

Panel 5 -- (Spirit, impatiently) COMMISSIONER DOLAN...

Panel 6 -- (Spirit, very impatiently) WHAT DO YOU MEAN YOU CAN'T? IT'S IN THE BACK ROOM!
(Dolan) THE BACK ROOM IS EMPTY!

Panel 7 -- (Jeering Audience) HA HA! HA HA! FAKE! HA HA HA HA HA!

Panel 8 -- Caption: LATER... [P.S. is back on Earth, holding some outlandish Martian artifact, still sucking his candy stick. Dolan absent-mindedly notices him but doesn't see the saucer behind them, or the Martian who is even now running eagerly toward it.]
(Dolan) OH, THERE YOU ARE, P.S. WHERE'D YOU PICK UP THAT DUMB-LOOKING TOY!

Panel 9 -- Caption: MEANWHILE... [and we see that the poor battered Martian has finally made it back into outer space, as the saucer heads toward Mars.]

THE END

ABOVE: This is an example of a typical script style. This allows the artist to innovate page layouts and panel composition.

THE DUMMY

For the graphic medium, the conceptual layout is an almost inescapable requirement. In advertising it is called a layout or mechanical, in filmmaking it is a storyboard and in comics it is a "dummy."

This device functions as a trial mock-up which gives the creator the chance to make rearrangements before the final product is begun. In comics a dummy is an indispensable tool because successful graphic storytelling depends on the ability of the text and imagery arrangement to convey the narrative and hold the reader's attention. This instrument provides the editor, writer and artist with control of story and art. The time- and money-saving advantages are obvious.

For an individual comics creator, dummies can be as simple as arranging reference photos in panel order or as complicated as detailed sketches that show exactly what the penciled art will look like. The point of the dummy is to help an artist arrange the details of a comic before committing himself to art or storytelling which doesn't work. In comics created digitally, changes are often applied to the dummy itself, transforming it into the final art.

The following dummy shows several pages from the graphic novel *To the Heart of the Storm*. It was executed on 8½" x 11" typewriter sheets, approximately the size and shape of the final printed page. The inked page is shown alongside the final version (see FIGURES 105 through 108).

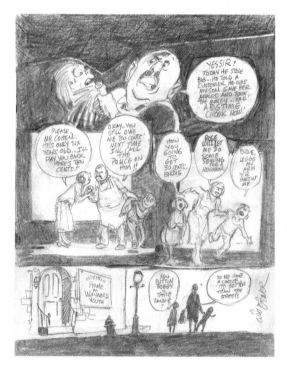

FIGURE 105

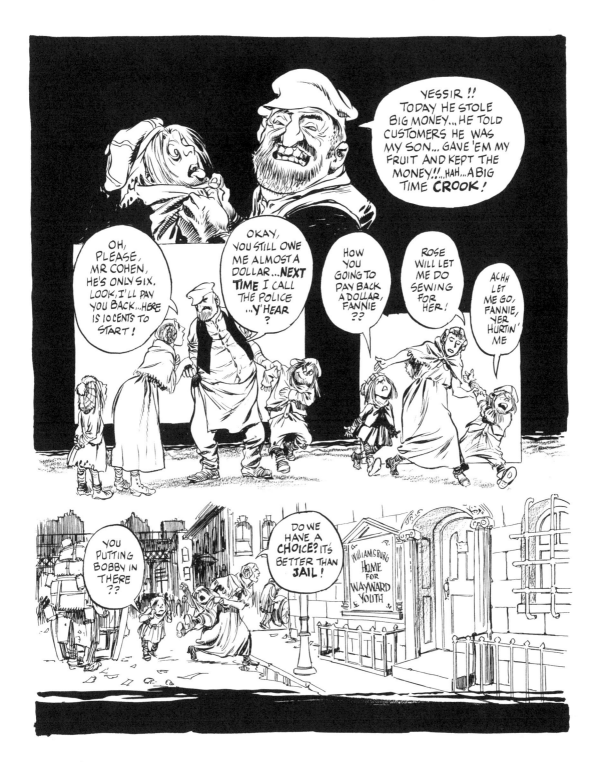

FIGURE 106

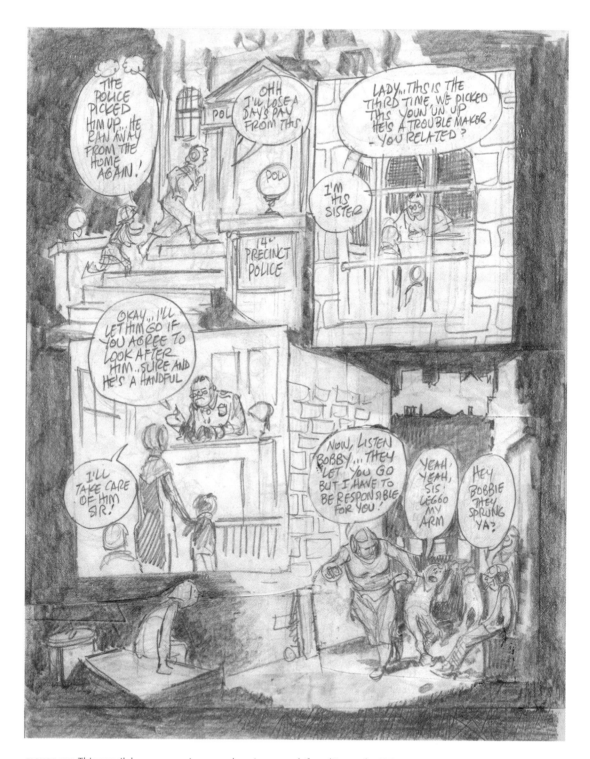

FIGURE 107: This pencil dummy page is comprehensive enough for editor and artist.

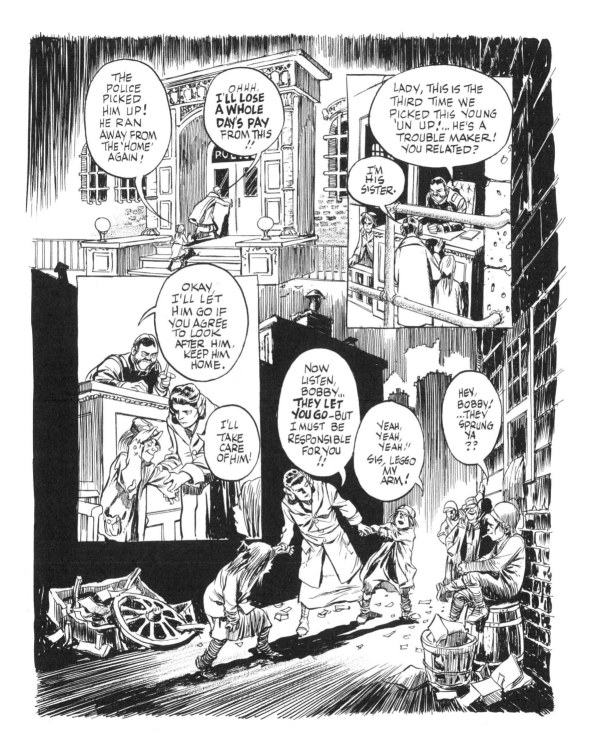

FIGURE 108: The inking shows refinements in posture and layout. Working from a dummy, the artist enjoys a great deal of freedom in that there is an already determined underlying structure upon which the rendering can depend.

CHAPTER 7

APPLICATION: THE USE OF SEQUENTIAL ART

In general terms we can divide the functions of sequential art into two broad applications: instruction and entertainment. Periodical comics, graphic novels, digital or Webcomics, instructional manuals and storyboards are the most familiar vehicles. In the main, periodical comics, graphic novels and Webcomics are devoted to entertainment, while manuals and storyboards are used to instruct or sell. But there is an overlap because art in sequence tends to be expository. For instance, comic books, which generally confine themselves to stories designed exclusively for entertainment, often employ instructional techniques that buttress the exaggeration and enhance the entertainment. In a work of comic art intended purely for entertainment, some technical exposition of a precise nature often occurs. A common example is a procedure like the opening of a safe in a detective story or the assembling of parts in a space adventure. The technical passage in FIGURE 109 is actually a set of images with an instructional message embedded in an entertaining story.

In the case of a purely instructional comic, particularly in the case of a behavioral or attitudinal piece (explained more thoroughly later in this chapter), the specifics of the information are frequently overly larded with humor (exaggeration) to attract the reader's attention, convey relevance, and set up visual analogies and recognizable life situations. This inserts entertainment into a technical work.

ENTERTAINMENT COMICS

Obviously sequential art is not without limitations. An image, wordlessly depicting a gesture or a scene, can, for example, convey depths and a certain amount of emotion. But as we observed earlier in the discussion on writing, images are specific, so they obviate interpretation. An assem-

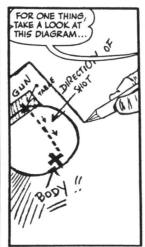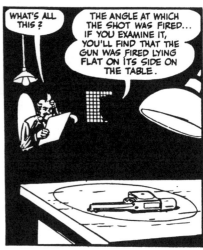

FIGURE 109: In this three-panel sequence from the *Spirit* story "The Guilty Gun" (June 6, 1948), an "entertainment" comic, the technical ballistics information needed for reader comprehension is imparted subtly enough that it does not detract from the forward motion of the plot.

blage of art that portrays life allows little input of an imaginative nature from the reader. However, the recognition of real-life people portrayed and the addition of "in-between" action are supplied by the reader out of his own experiences. In the main, though, these requirements on the reader are set down with precision by the art.

There is a kind of privacy that the reader of a traditional prose work enjoys in the process of translating a descriptive passage into a visual image in the mind. This is a very personal thing and permits an involvement far more participatory than the voyeurism of examining a picture.

Another challenge to the sequential art medium is the matter of dealing with abstraction. Obviously, when the comic artist selects a single posture out of a chain of motions by a body—or an arrested moment in the animation of objects in movement—there is little time (or space) to deal with the intangibles of, say, the surge of pain or the glow of love or the turmoil of inner conflicts. When faced with this task, the demand on the innovativeness and creativity of

the comic artist becomes enormous. Yet it is precisely in these areas where the opportunity for expansion of the application of comic book art lies. This is the prime and continuous confrontation that the comic book cartoonist must address. There are only two ways to deal with it: to try, and risk failure, or not to do it at all—that is, to avoid any subject not easily expressed by the present state of the art or its existing clichés.

THE GRAPHIC NOVEL

Over the past three decades a new horizon has come into sharp focus with the emergence of the graphic novel, a form of comic book that is currently the fastest-growing literary medium in America. For an earlier generation comics were confined to short narrations or depictions of episodes of brief but intense duration. Indeed, the reader, it was assumed, sought from comics either instant visually transmittable information, as in

daily strips, or a visual experience of a sensory nature, as in fantasy comics. Between 1940 and the early 1960s the industry commonly accepted the profile of the average comic book reader as that of a "ten-year-old from Iowa." In adults the reading of comic books for many years was regarded as a sign of low intelligence. Publishers neither encouraged nor supported anything more.

This attitude had old origins: early tapestries, friezes or hieroglyphic narrations either recorded events or sought to reinforce mythologies; they spoke to a broad audience. In the Middle Ages, when sequential art sought to tell morality tales or religious stories with no great depth of discussion or nuance, the readership addressed was presumed to be one with little formal education. In this way, sequential art developed into a kind of shorthand that employed stereotypes when addressing human involvement. Those readers who sought greater sophistication of subject and greater subtlety and complexity of narrative could find it more easily by learning how to read words.

In the middle of the twentieth century, sequential artists moved toward long-form works, broadly called "graphic novels" (a term which can encompass works of nonfiction in addition to works that are truly novelistic).

Both markets and attitudes have dramatically changed since the late 1970s. The continued growth and acceptance of the graphic novel can be attributed to creators' choice of wide-ranging and worthwhile themes and in the continuing innovation of exposition. Despite the proliferation of digital and electronic technology, the portable printed page won't disappear in the immediate future, and thus it would seem that the attraction of broader and more discerning audiences to printed graphic novels lies in the hands of serious comic book artists and writers who are willing to risk trial and error. Publishers are only catalysts. No more should be expected from them.

The future of this form depends on participants who truly believe that the application of sequential art, with its interweaving of words and pictures, provides a dimension of communication that contributes—with increasing prominence—to the body of literature that concerns itself with the examination of human experience. Style, presentation, economy of space and the technological nature of reproduction notwithstanding, balloons and panels are still the basic tools of the sequential artist. The art, then, is that of deploying images and words, each in exquisitely balanced proportion with the other, within the limitations of the medium and with ambitious narratives and themes to attract and challenge ever more sophisticated and critical audiences.

The book market, for many decades either hostile or indifferent to comics, has in recent years accepted and even embraced the best graphic novels. No longer confined to comic book shops, independent bookstores, chains and online retailers all now devote considerable space to American graphic novels and to imported Japanese *manga* and works from Europe. Prestigious literary awards are no longer off limits to graphic novelists and serious sequential art is written about and reviewed in a wide variety of popular and esoteric publications. Even Hollywood, which has for years produced blockbuster adaptations of comics about costumed superheroes, is also making movies inspired by alternative and literary comics (*The Spirit* among them). Cartooning *auteurs* need no longer feel like cultural outcasts.

ABOVE: Four highly acclaimed American graphic novels: *A Contract With God* (1978) by Will Eisner, *Maus* (1973–1991) by Art Speigelman, *Kings in Disguise* (1988) by James Vance and Dan Burr, and *Fun Home* (2006) by Alison Bechdel. These books have not only won comic book industry awards like the Eisners and the Harveys (awards comparable to film's Oscars), but have also won or been nominated for awards that have traditionally been limited to non-graphic works like the National Book Critics Circle Awards, the *Los Angeles Times* Book Awards, and the Pulitzer Prize.

WEBCOMICS

Alongside the acceptance of the graphic novel as a literary art form, the growth of interest in Webcomics has been the hallmark of the last two decades. Webcomics have grown to not only be a solid training ground for new and developing artists but a financially feasible alternative to expensive print publishing, and the electronic format permits a potentially international audience, even to new artists. Webcomics encompass all genres, from traditional gag cartoons to sophisticated online graphic novels and experimental digital art.

With the universal popularity of the Internet and the burgeoning of digital media, Webcomics offer a more immediate reading experience, with content being updated without the months-long lead times of print publishing. The relationship between the creator and the reader, too, has become a more intimate one with the advent of blogs and online forums offering unique opportunities for immediate creator/reader and reader/reader interaction.

TECHNICAL INSTRUCTIONAL COMICS

In the arena of instructional visuals—or the application of sequential art to teach something specific—the limitations that afflict purely entertaining comics are less problematic. There are

RIGHT, TOP AND BOTTOM: This example of a "Joe Dope" story appeared in *P*S Magazine: the Preventive Maintenance Monthly*, published by the Department of Defense.

ABOVE: These are sample pages from an operator's manual used by the military. It shows a more formal layout that retains the function of panels and balloons.

two forms of instructional comics: technical and attitudinal.

A purely "technical" comic, in which the procedure to be learned is shown from the reader's point of view, gives instruction in procedure, process, and task performance generally associated with such things as assemblies of devices or their repair. The performance of such tasks are, in themselves, sequential in nature, and the success of this art form as a teaching tool lies in the fact that the reader can easily relate to the experience demonstrated. For example, the most successful exposition of a procedure is one that is shown from the reader's perspective. Here the arrangement of panels, the position of the balloons and/ or explanatory text carefully arranged on a page are all calculated to involve the reader. Properly done, these elements should combine to provide the reader a familiarity with the subject of the comic born out of the experience that sequential art is so good at providing.

ATTITUDINAL INSTRUCTION COMICS

Another instructional function of sequential art is conditioning an attitude toward a task. The relationship or the identification evoked by the acting out or dramatization in a sequence of pictures is

ABOVE AND OVERLEAF: Designed for career exploration by readers in grades 4 to 12, *Job Scene* booklets give students a sense of personal responsibility for their careers. They stress the potency and dignity of work, introduce a wide variety of job opportunities, stimulate interest and whet curiosity.

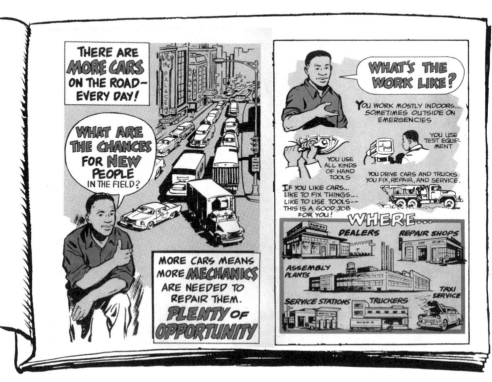

in itself instructional. People learn by imitation and the reader in this instance can easily supply the intermediate or connecting action from his or her own experience. Here too there is no pressure of time as there would be in a live-action motion picture or animated film. The amount of time allowed to the reader of a printed comic to examine, digest and imagine the process of acting out or assuming the role or attitude demonstrated is unlimited. There is room for approximation and opportunity for specific performances, which the reader can examine without pressure. Unlike the rigidity of photographs, the broad generalization of artwork permits exaggeration, which can more quickly make the point and influence the reader.

STORYBOARDS

Storyboards are still scenes for motion pictures, pre-planned and laid out in hand-painted or drawn frames. While they employ the major elements of sequential art, they depart from comic books and strips in that they dispense with balloons and variable panels, instead having notations of dialogue, camera shifts, and sound effects below panels that mimic the proportions of a television or movie screen. Storyboards are not meant to be read but rather bridge the gap between a screenplay and the final photography of a film. The storyboard is where many technical and artistic decisions about how a film will be made and how it will look are determined. In the same way that a comic book artist considers how to frame a scene within a panel, a storyboard artist will suggest shots (camera angles) and envision the placement of actors and lighting.

With the ever-growing popularity of computer-animated films and special effects, the need for carefully planned storyboards becomes obvious. Because of the fundamental relationship between film and comics (which preceded film), it is little surprise that the employment of comic book artists by filmmakers has boomed. In addition to storyboards prepared for film, some comic books serve as storyboards for their own film adaptations.

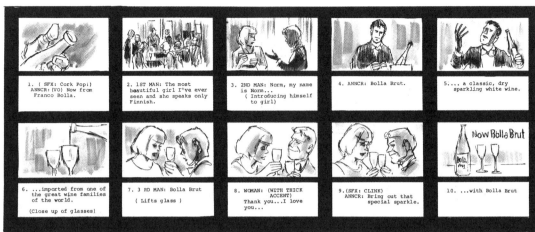

1. (SFX: Cork Pop!)
 ANNCR: (VO) Now from Franco Bolla.

2. 1ST MAN: The most beautiful girl I've ever seen and she speaks only Finnish.

3. 2ND MAN: Norm, my name is Norm...
 (Introducing himself to girl)

4. ANNCR: Bolla Brut.

5. ... a classic, dry sparkling white wine.

6. ...imported from one of the great wine families of the world.
 (Close up of glasses)

7. 3 RD MAN: Bolla Brut
 (Lifts glass)

8. WOMAN: (WITH THICK ACCENT)
 Thank you...I love you...

9. (SFX: CLINK)
 ANNCR: Bring out that special sparkle.

10. ...with Bolla Brut

BOLLA BRUT, "Party F/P," The Joseph Garneau Company, Copyright 1984.

(SFX: CORK POP!)
ANNCR: (VO) Now from Franco Bolla,

1ST MAN: The most beautiful girl I've ever seen and she speaks only Finnish.

2ND MAN: Norm. My name is Norm...

ANNCR: Bolla Brut,

a classic, dry sparkling white wine

imported from one of the great wine families of the world.

3RD MAN: Bolla Brut.

WOMAN: (WITH THICK ACCENT) Thank you...I love you...

(SFX: CLINK)
ANNCR: Bring out that special sparkle...

with Bolla Brut.

ABOVE: Here is an example of a storyboard for a television commercial and corresponding excerpts from the resulting footage.

EDITOR'S NOTE The detailed discussion in this chapter of instructional comics, which occupy a fairly small section of the world of comics, is evidence of Will Eisner's long career and experience with this aspect of the medium. From 1942 to 1945 Eisner served three years as a Warrant Officer in the Pentagon in Washington, D.C., where, during World War II, he created motivational posters and pioneered the use of cartoons for instructional purposes with the publication *Army Motors*. His innovative approach, combining hard information within cartoon plots, proved so effective that he privately contracted with the U.S. Army in 1951 to produce *P*S, The Preventive Maintenance Monthly* and continued to produce the magazine for many years afterward. He formed American Visuals Corporation in 1948 to supply similar educational comics to clients ranging from the U.S. Government's Job Corps to General Motors and also formed a separate company which produced a wide array of cartoon-based educational materials for schools across America. This background in instructional comics makes Eisner an unparalleled resource for information about the form and explains the prominence they are given in Eisner's view of the application of sequential art.

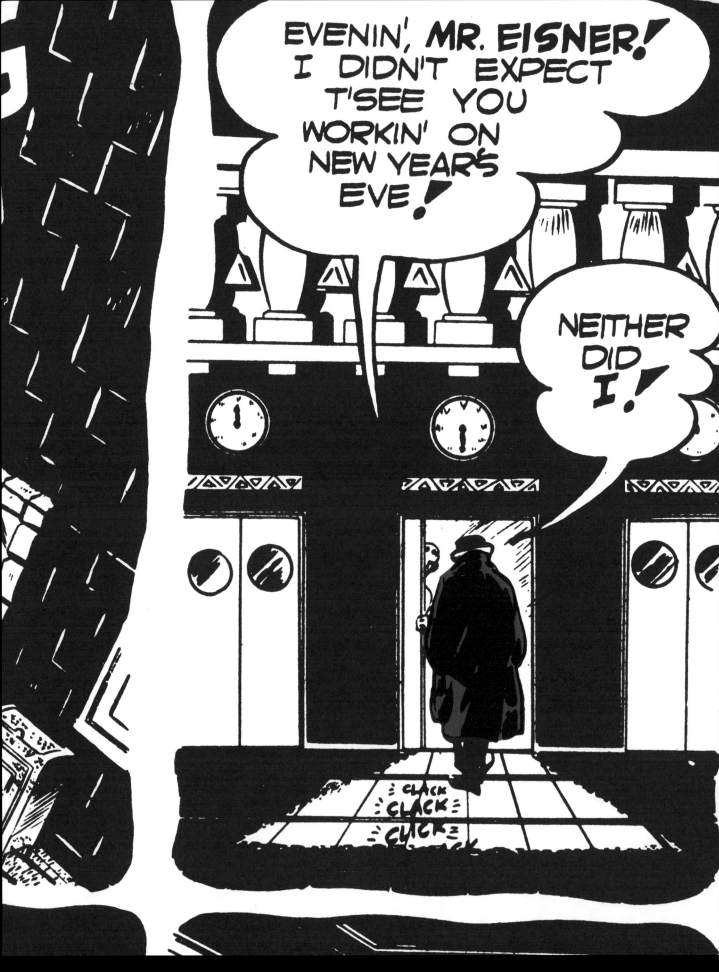

CHAPTER 8

TEACHING AND LEARNING SEQUENTIAL ART FOR COMICS IN THE PRINT AND DIGITAL AGE

Sequential art, especially as it is applied to comics, is primarily intended for reproduction, either in print or online. Therefore, in educating a sequential artist, aesthetics and technical skills must be addressed almost simultaneously. There is little opportunity for serendipity in this discipline.

Particularly in comics, the practice of sequential art is a teachable, studied skill that stems from an imaginative employment of scientific, linguistic and literary knowledge as well as the ability to portray or caricature and to handle the tools of drawing, whether those tools are pencil and paper or a drawing tablet connected to a computer. Indeed, an average comic book story would reveal the involvement of a range of diverse disciplines that would surprise a pedagogue.

It is worth the risk of over-simplification to attempt a charting of these to make the point (see FIGURE 110).

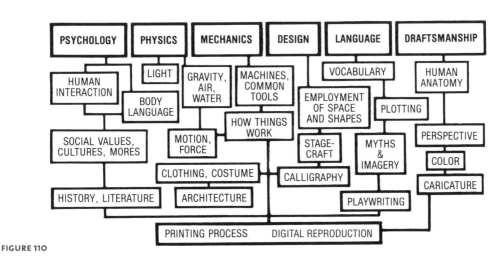

FIGURE 110

PREPARATION

A fundamental command of drawing and writing is a prerequisite for creating sequential art. This is an art form that concerns itself with realism because it tells stories. Sequential art deals with recognizable imagery. The tools are human (or animal) beings, objects and devices, natural phenomena and language. Obviously a serious study of available textbooks or courses in anatomy, perspective design and composition are important preparation. Each of these disciplines is a study in itself, and should be a part of the student's course of training. In addition to these widely accessible areas of study, there are also now several schools with specific comics curricula, including the Center for Cartoon Studies in White River Junction, Vermont; the Joe Kubert School of Cartoon and Graphic Art in Dover, New Jersey; and the School of Visual Arts in New York City. (Note: see "Schools Offering Courses in Comics Creation" on page 173 for more information about studying comics creation.) A steady diet of reading, particularly (but by no means exclusively) in the short story form, is essential to developing plotting and narrative skills. Reading fiction stimulates the student's imagination so he will be better able to "imagine" for the reader. Reading also provides a usable bank of information. In an art form where the author/artist must have at his command a wide body of quickly retrievable facts and information about innumerable subjects, the input of knowledge is never-ending. After all, this is an art form that deals with human experience.

HOW TO LOOK AT THINGS

How the artist sees life and the objects with which he must deal lies at the heart of the skill with which he employs them. Objects, how they work and how to represent them, must be seen fundamentally in order to understand them.

Here are a few basic elements of phenomena and imagery whose details the artist must comprehend. They are selected out of a whole universe of subjects that must be understood.

THE HUMAN MACHINE Consider the human (or animal) body as a mechanical device. As such, it has a limited range of movement. Understanding what it can or cannot do is critical to its manipulation (see FIGURE 111).

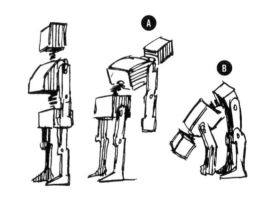

FIGURE 111: Ⓐ Maximum back. **Ⓑ** Maximum forward.

PERSPECTIVE Distance, relationship of one shape to another, configuration and size is shown on a one-dimensional surface by the use of lines that ultimately converge upon a point on the horizon, called a "vanishing point" (see FIGURE 112).

LIGHT/SHADE Light from its source should be perceived as a flow of water. The absence of light is darkness. An object interrupting a flow of light is dark on the side facing away from it. All objects of a group under the same light source will have a side (or shadow) on the side away from it. All objects in a flow of light throw a shadow onto whatever is behind it—wall, floor or another object. Shadows conform to the surface of the

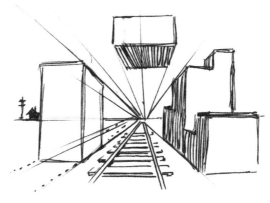

FIGURE 112

shape upon which they fall (see FIGURE 113). The employment of light has an emotional effect. Shadow evokes fear, while light implies safety (see FIGURE 114).

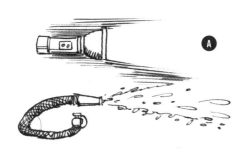

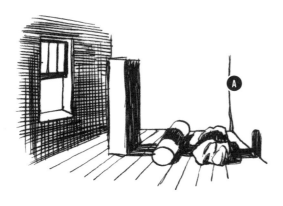

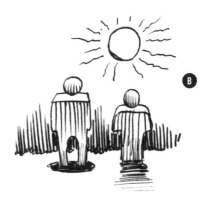

FIGURE 113: **Ⓐ** Controlled source. **Ⓑ** Undirected source.

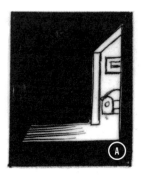
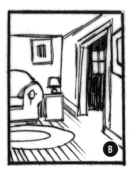

FIGURE 114: **Ⓐ** The unknown. **Ⓑ** The known. **Ⓒ** Threat. **Ⓓ** Candor.

FIGURE 115: Even a table lamp has anatomy.

FIGURE 116: Casual props must work accurately. For example, understand how a door is hinged.

OBJECTS ALL objects with which people live are essentially machines. From a simple empty box to an automobile they have an anatomy and a limited range of operating capability. In this they should be considered as you would a human body (see FIGURE 115).

DEVICES Understand how they work! The reader will know how they *should* work and will respond negatively if you are inaccurate. This holds true in realistic as well as in humorously exaggerated cartoons (see FIGURE 116).

GRAVITY Everything on the surface of the earth responds to gravitational force. This is a phenomenon that human beings struggle with continually. Its use as a storytelling device is therefore widespread and commonly understood (see FIGURES 117 and 118).

DRAPERY All cloth on an object or body responds to the force of gravity! Its response to that force depends on the shape of the gravity-defying object underneath (see FIGURES 119 and 120).

FIGURE 117: The weight of an object affects the result of its response to the force of gravity.

FIGURE 118: Gravity-defying object. **Ⓐ** Soft cloth. **Ⓑ** Flat surface.

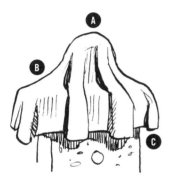

FIGURE 119: **Ⓐ** Pinch points (points on an underlying object that support cloth). **Ⓑ** Draping effect (sag in cloth). **Ⓒ** Fluting (occurs when the unsupported cloth responds to the downward pull of gravity).

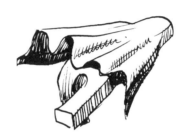

FIGURE 120: Gravity-defying objects in motion (pull of action helps cloth defy gravity).

CARTOONING The cartoon is the result of exaggeration and simplification. Realism is adherence to most of the mechanical or anatomical detail. The elimination of some of the detail in an image makes it easier to digest and can add to humor. Retention of detail begets believability because it is closest to what the reader actually sees. The cartoon is a form of impressionism (see FIGURE 121).

COMPOSITION Each panel should be regarded as a stage wherein an arrangement of elements takes place. They must be arranged with a clear purpose. Nothing in a panel or page should be accidental or placed there casually. The primary consideration in composing a scene is the center of attention. The

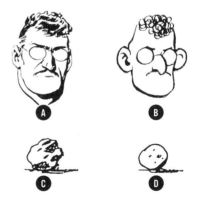

FIGURE 121: **Ⓐ** Realistic rendering. **Ⓑ** Cartoon rendering. **Ⓒ** Realistic rock. **Ⓓ** Cartoon rock.

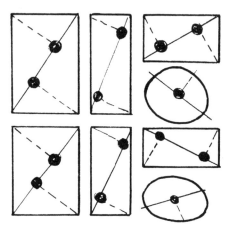

FIGURE 122: Each panel is a geometric shape.

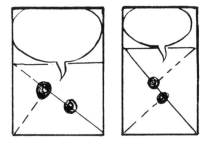

FIGURE 123: The FOCAL POINTS in any given panel occur at the point where a perpendicular line from opposite corners intersects with a diagonal from the remaining corners. These areas can be effectively used to position a vital object or action.

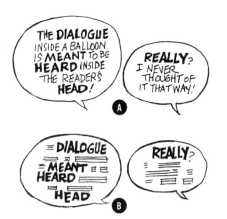

FIGURE 124: Ⓐ Bold face for emphasis. Ⓑ "Telegraphing" as it is scanned.

mission is to focus on the major item or action by placing it in the area of major attention. The panel is a geometric shape and has a focal point that the reader's eye first engages before moving on to absorb the rest of the scene. Each panel has its own focal point depending on its shape (see FIGURE 122).

Where a "balloon" dominates the major portion of a panel, the remaining area is the box, which becomes subject to a focal point (see FIGURE 123).

CAUTION! *The student should be warned that "focal points," unlike the rules of perspective, are employed as a rule of thumb and not a fact of reality. The "points" are to be understood as "areas." The selection and determination of the item or action to be placed there is a value judgment. They are an aid in the act of composing a scene.*

BALLOONS Think of balloons—I mean the dialogue *within* balloons—as being repeated by the reader inside his head. Act out the speech—for that is what the reader will do internally. Keep in mind you are dealing with sound. Emphasis is dealt with by the use of boldface lettering. Remember that the reader's first action is to scan the page, then the panel. If the pictorial value of the images is very exciting or filled with great detail, there will be a tendency to skim the balloon text. So a wise defensive stratagem is to try to deploy the boldface not only in service of sound but to "telegraph" the message (see FIGURE 124). The reader should be able to get the thrust or sense of the dialogue out of the boldface letters alone. Avoid hyphenation at the right margins: it tends to slow reading. Don't lose sight of the fact that there is a time lapse between panels. Therefore dialogue jumping in MID-SENTENCE from panel to panel will often look inept and could make the action diffi-

cult to follow…or downright silly (see FIGURE 125). Three or four balloons coming out of the same figure in one panel is a device I personally avoid because I think it is destructive to action flow (see FIGURE 126). As a rule I would advise that the dialogue be edited down (thirty words to a balloon is maximum for convenient reading) or split and placed in an added panel.

VISUALS VS. ILLUSTRATION In comics the drawings are visuals. In textbooks they are illustrations. A visual replaces text; an illustration simply repeats or amplifies, decorates or sets a climate for mood. Think of your function as a *visualizer* rather than as an *illustrator* (see FIGURE 127).

TECHNOLOGY (PRINT)

Across the twentieth century, sequential art found its outlet substantially in print media such as comic book magazines and newspaper strips. Today, the practice of comics still requires one to prepare artwork for print production. The artist's work must be reproducible according to the publisher's specifications, for it is the publisher who determines the method of publication, whether it be in print, online or both.

REPRODUCTION VS. RENDERING STYLE Artwork is rendered in response to the method of its reproduction. Early comic strips were drawn in simplified black line because newspapers and magazines were mostly printed by the letterpress method (see FIGURE 128A). Halftone (grays) engraving was crude and the screens used were very coarse. Furthermore, the line work had to be sturdy so that it could survive web press printing on the coarse surface of cheap newsprint and

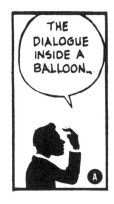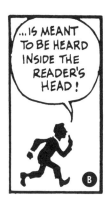

FIGURE 125: Splitting the balloon. Too much time has elapsed between panels to retain the thought. **A** Panel 1. **B** Panel 2.

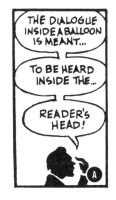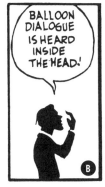

FIGURE 126: Editing the balloon. **A** Original: too many balloons for a single speech also slows the action. **B** Alteration: this editing frees the visual and so speeds the action.

FIGURE 127: **A** An illustration. **B** A visual.

pulp paper. With the development of offset printing, in which a plate is chemically treated to retain or repel ink, reproduction of drawings with more delicate lines became more viable (see FIGURE 128B). Rotogravure printing of comics was never very widespread in American publishing and had little impact on the style of rendering comic art (see FIGURE 128C).

Later, as color was added, it was done so by the application of overlays called "hand-separation." The intended color was placed into each area of the art, like the paint-by-number images in some children's coloring books. Specialists in the engraver's plant then mechanically applied color, so the artist had to render his drawings such that the line work trapped or provided a clearly defined containment for the color. Vignettes (images with shaded edges or not enclosed by borders) were, therefore, impractical (see FIGURES 128D and 129).

In effect, the artist was at the mercy of the people in the engraver's shop and their competence.

Today, with the advent of digital photography, inexpensive yet high-quality flatbed scanning, computer manipulation and digital plate-

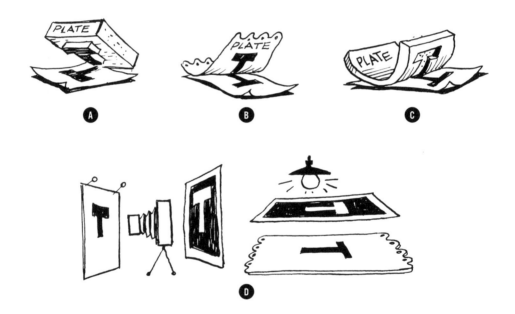

FIGURE 128: Printing: classically, printing is the transfer of an image engraved on a plate, after it has been coated with a film of ink, onto the surface of paper. There are three basic systems. **A** Letterpress: the impression left by a rubber stamp's raised surface is a kind of letterpress printing. **B** Offset: like an offset print, a fingerprint is created by the chemical differences on a surface. **C** Rotogravure: the ink from inside an image cut into metal as in an etching. **D** Engraving: the image on the original art is transferred to the printing plate.

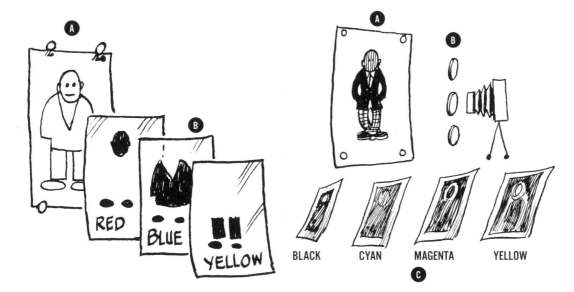

FIGURE 129: Color (hand-separation): this demonstrates why line work (in comics) tended toward lines that "trapped" color. **Ⓐ** Original art. **Ⓑ** Overlays: the three primary colors.

FIGURE 130: Color (process separation). **Ⓐ** Original art in full color. **Ⓑ** Filter for three primary colors. (In the four-color printing process, printers use magenta and cyan, which blend with yellow to form red, blue and other hues.) **Ⓒ** Negatives.

making, the whole work can go from artist's studio to printing plates, via email, in a matter of hours (see FIGURE 130).

DIGITAL ART AND THE PC

Before the arrival of the personal computer most comics and illustration were prepared for reproduction by what in the future will be regarded as a primitive process. Because of this process the artist had to acquire drawing skills with steel tip pens, sable brushes and pencil. Artwork was delivered to the printer on illustration or Bristol board, often with "zip-a-tone" shading (an alternative to hatching that involved transferring patterns from pre-printed sheets) or overlays indicating grey tones. This hands-on material unquestionably influenced style and even the level of detail the creator was able to achieve. Many professional cartoonists still create in this traditional manner. But computers, with specialized drawing software and tools like drawing tablets, increase the productive capacity of a comics creator by enabling the addition of artistic and design elements such as backgrounds, coloring and lettering with only the tap of a button and the wave of a mouse. The nearly infinite possibilities of digital creation enable myriad styles and methods of expression, moving comics beyond a universal "comic book style" and allowing comics creation by those with a solid grasp of aesthetics and narrative but who lack traditional drafting skills.

As digital technology expands beyond desktops and laptops to include mobile phones, PDAs and the like, so will the creative options of digital production and delivery for sequential artists.

THE PROCESS

There are only a few general vehicles for transmitting comics: in print, online, on disc and as video. Here we will discuss print. In modern times, art for reproduction will reach the printer via computer in the manner outlined in FIGURE 131.

Before artwork can be used on a computer it must first be scanned. This converts it to a digital format. Artwork can also be created directly on a computer by using a digital drawing tablet, which will do the same thing. On a computer, line art may be either created as a bitmap (an image comprised of pixels and which is a fixed size) or as a vector image. Vector images are created using programs which convert an artist's drawing into a mathematic equation, enabling it to be reproduced at any size without losing image quality. To add color to line art there are paint programs that apply color in layers overlaying the line art without altering it. This can be done with one overlay for all necessary color or by using several overlays, each layer of which can be manipulated individually (see FIGURE 132). Of course, an artist may also choose to forgo the traditional line art/coloring process or he may choose to "color" using manipulated digital photographs or vector patterns.

BLACK RED YELLO BLUE

FIGURE 131

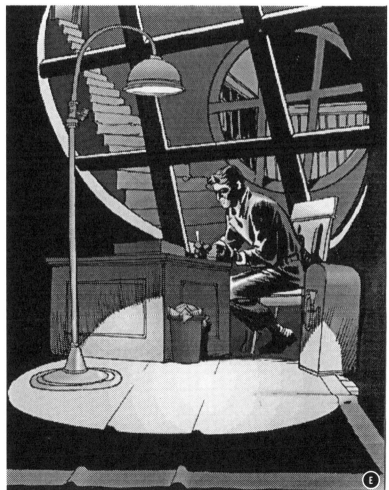

FIGURE 132: All of the above coloring and shading is done on screen after basic art is scanned. **A** Line art. **B** Layer 1. **C** Layer 2. **D** Layer 3. **E** Completed picture.

COMICS ON THE INTERNET

Historically, comics were created for a page or panel or strips which were part of either a magazine or newspaper. The widespread acceptance of the Internet by publishers and the news media itself threatens to eventually replace print as the major vehicle for comic strips. Now it is certainly more than an alternative to print. A consideration of how digital technology affects the medium is therefore needed.

There is a certain dynamic of tactility and space in print that is very different from the "feel" of an image on a monitor. We must not lose sight of the basic fact that sequential art is a literary medium that narrates by the arrangement of images and text in an intelligible sequence. Regardless of the method of delivery, the fundamental require-ments of sequential art remain the same. These fundamentals are:

NARRATIVE: The "story" must adhere to a common reading convention.
COMPOSITION: Panels and groups of panels must be composed for narrative purposes.
CHARACTERS: The skillful creation of "actors."
DRAFTSMANSHIP: The quality of rendering of the elements portrayed.

As long as comics remains a medium which does not have motion, sound or three-dimension-ality, the narrative process is the same.

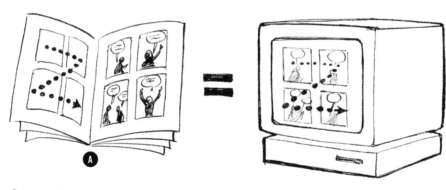

FIGURE 133: ❹ Conventional reading sequence.

DIGITAL DELIVERY

When a comic is displayed on the monitor as a page, the viewer reads it in a manner similar to print. So the arrangement of panels and the com-posing of scenes as well as balloons adhere to print rules (see FIGURE 133).

Because of the flexibility of panel arrangement in digital comics, the page layout can be exper-imented with so that the reading rhythm will be altered to deal with screen-reading vs. print-reading. In doing so, it may be useful for a comics

artist to study the principles of Web design, which concern themselves with exactly this question.

A page can be reproduced online in the same proportion as a printed comic, requiring the reader to scroll down the page. An alternative is to arrange the page in a format that fits the proportions of a monitor.

Some artists choose to experiment with the "infinite canvas" of the Internet, by arranging the artwork in such a way that the reader scrolls through the arrangement of panels and text, following different narrative pathways or utilizing interactive features to enhance the storytelling experience.

FIGURE 134 shows an example of "playing" with an arrangement to reach a satisfactory page layout.

FIGURE 135 shows an alternative in the form of a panel-by-panel presentation.

This of course eliminates the need for the employment of the conventional panel arrangement. The traditional function of the panel as a punctuation or as an emotion-orientation no longer applies. The concentration then is on acting and composition of the scene. The posture and gesture of the actors must be more obvious to be immediately understood because the viewer will move more hurriedly from scene to scene. A conventional comic is subject to a different reading rhythm. On a print page where the reader first scans all the panels on the page, the concentration on each panel is more leisurely. But in either case the action is suggested, time is perceived and sound is implied. As the technology of transmis-

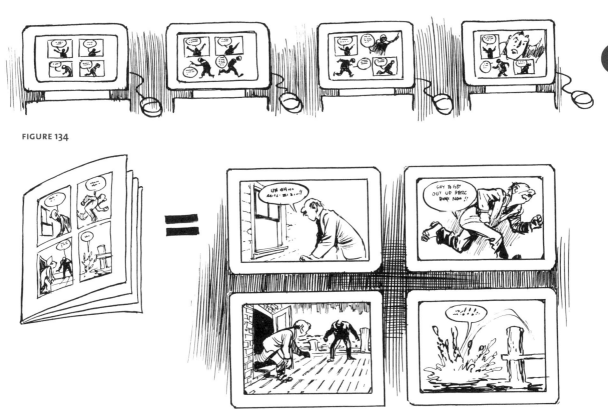

FIGURE 134

FIGURE 135: This is the same comic told in an unpaneled sequence.

sion improves so that images appear more quickly and the resolution is sharper, the art is able to be increasingly detailed. Individual style or "art personality" as a contribution to emotional content should not be dismissed.

INDIVIDUALITY AND PERSONALITY IN THE DIGITAL AGE

Traditionally art, its style and individuality, has been central to the personality of a comic book or strip. This generally results from a singular ability with pencil, pen or brush and has an impact on the narrative quality of the work. One might say that style is a form of imperfection.

Technology has always had the effect of expanding an artist's reach while challenging their individuality. With the arrival of computers capable of generating artwork, rather than simply reproducing it, came a new impact on individuality. Old skills with more primitive tools are being replaced by new skills with a mouse or a stylus with which one draws an image while looking at a screen separated from the surface on which the image is being manipulated. The creator can now mechanically produce technically perfect perspectives and geometrically accurate shapes. Thousands of color combinations that are automatically mixed and patterns of dazzling complexity can be produced by the touch of a button, and they add enormously to the creator's range. But since anyone with the same machine can do the same thing, the creator will have to go beyond a simple manipulation of a machine in order to generate images that are singular, stylistic and idiosyncratic, reflecting the artists' distinctive personality.

All the evidence at hand indicates that personality or individuality in the practice of sequential art will continue to come from its combination with the generation of ideas and mastery of narrative style.

SCHOOLS OFFERING COURSES IN COMICS CREATION

• Center for Cartoon Studies, White River Junction, VT
• Joe Kubert School of Cartoon and Graphic Art, Dover, NJ
• Rhode Island School of Design, Providence, RI
• Savannah College of Art and Design, Savannah, GA
• School of Visual Arts, New York, NY

NOTE: This list is by no means exhaustive, and is intended to be a starting point for those looking for information on comics instruction. The National Association of Comics Art Educators keeps an up-to-date list of schools and resources on its Web site at www.teachingcomics.org/links.php.

INDEX

175

ABOUT THE AUTHOR

WILL EISNER (1917–2005) IS UNIVERSALLY ACKNOWL-edged as one of the great masters of comic book art, beginning as a teenager during the birth of the comic book industry in the mid-1930s. After a successful career as a packager of comic books for various publishers, he created a groundbreaking weekly newspaper comic book insert, *The Spirit*, which was syndicated worldwide for a dozen years and influenced countless other cartoonists, including Frank Miller, who wrote and directed the major motion picture based on it. In 1952, Eisner devoted himself to the then still nascent field of educational comics. Among these projects was *P*S*, a monthly technical manual utilizing comics, published by the United States Army for over two decades, and comics-based teaching material for schools. In the mid-1970s, Eisner returned to his first love, storytelling with sequential art. In 1978, he wrote and drew the pioneering graphic novel *A Contract With God*. He went on to create another twenty celebrated graphic novels. The Eisners, the comics industry's annual awards for excellence (equivalent to the Oscars in film), are named in his honor.

ALSO AVAILABLE